RADIOACTIVE

RADIOACTIVE

MARIE & PIERRE CURIE

A TALE

OF

LOVE & FALLOUT

by Lauren Redniss

It Books, An Imprint of Harper Collins

With apologies to Marie Curie,
who said,

"There is no connection between
my scientific work and
the facts of private life."

RADIUM

POLONIUM

"Let us first understand what we mean by the word *magic*. Magic is a mystery and we call a thing a mystery because we do not understand it. There are two magics and many mysteries which are not magical but what I wish to refer to now are those that come under the head of magic! There are two kinds of magics. I say magics in order to simplify what I mean. One kind is created by man, wherein he produces things which are magical or mysterious to everybody but himself because to him they are simple results due to natural causes which are manipulated by him.

"Then there are nature's magics — called magics because no man understands them. As soon as their causes are known to man they are no longer mysteries, no longer magics. They are natural results of material causes. Radium is one of these — Nature's magic, because as yet no one understands its being, or causes of being, nor its results of being. If Radium can bring to our vision those things which we cannot see (as it does the atom), its influence cannot be measured on materialists who say, 'I'll believe when I see.'

"If it can show us the soul as it leaves man by registering it on the photographic plate, if it can be the means of photographing our imagination, so that the eye can see it, what will we not believe, we materialists who think that only things we realized with our human senses are real. To see, to feel, to smell, to hear, to taste, these are only invisible facts — but which we acknowledge are real — the sensations of horror that kills, of grief that prostrates, joy that uplifts, and faith that cures — what if these things can be registered and seen apart from the body, are they not then material things? And may they not indicate that other invisible materials exist — which are in reality material if we had the human capacity for observing them?... Perhaps Radium and its sister elements may one day help us here. We may not believe, but we do not know that we should not believe!"

Loïe Fuller, "Lecture on Radium"
January 20, 1911, London, England

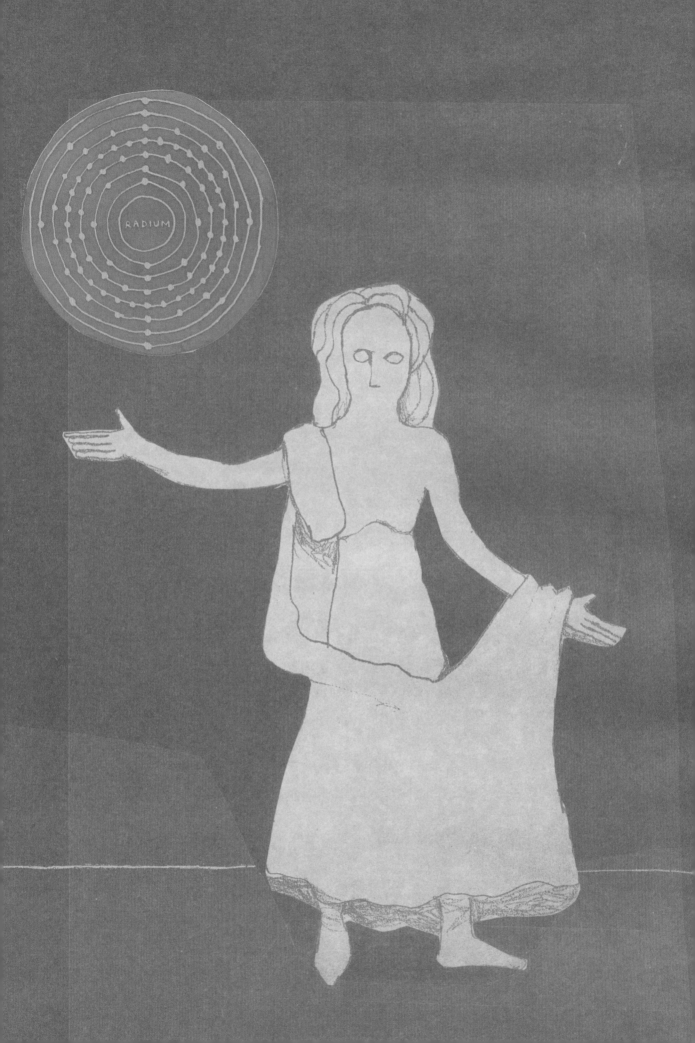

CONTENTS

PART

I

CHAPTER 1
SYMMETRY

"The sensitive plate, the gas which is
ionized, the fluorescent screen, are in
reality receivers, into another kind of
energy, chemical energy, ionic energy
. . . luminous energy."

—Marie Curie

Catastrophism, a geological theory championed by zoologist Georges Cuvier, holds that time lurches forward in sudden disasters. In Paris, there is a street named after Cuvier. It rolls downhill toward the Seine alongside a garden. On the rue Cuvier on May 15, 1859, Pierre Curie was born.

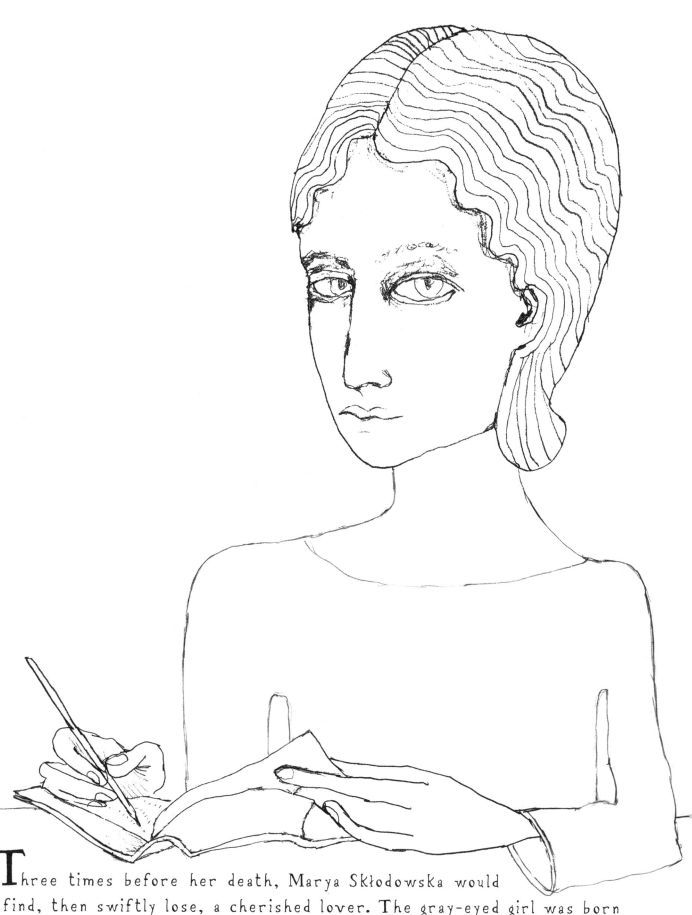

Three times before her death, Marya Skłodowska would find, then swiftly lose, a cherished lover. The gray-eyed girl was born in Warsaw on November 7, 1867, the year chemist and orchid cultivator Alfred Nobel patented dynamite. She would become famous as Marie Curie, twice winning the prize Nobel established with his explosives fortune. (15)

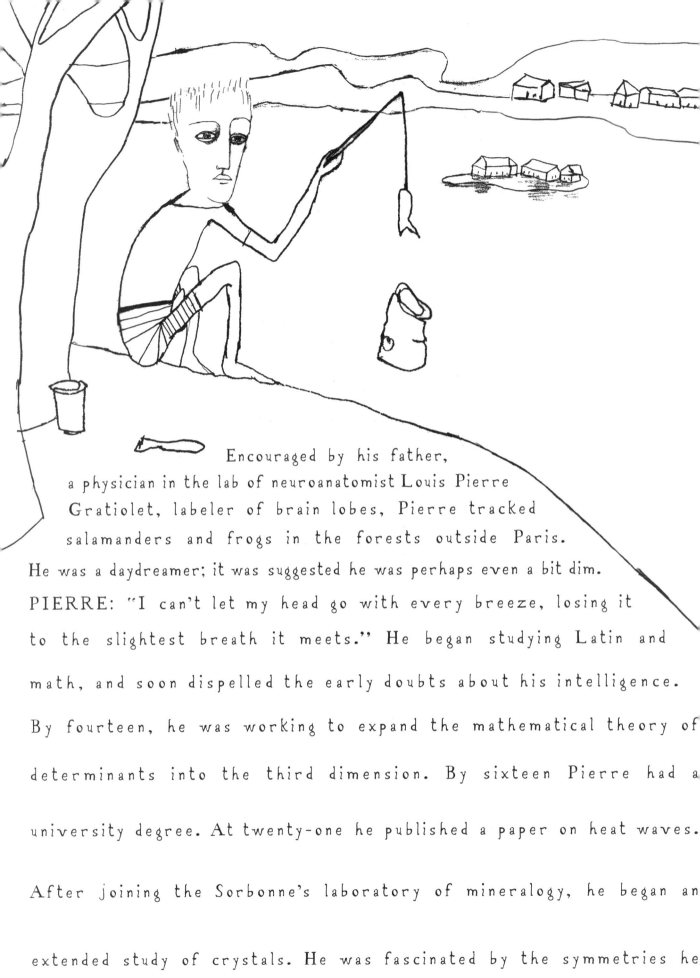

Encouraged by his father,
a physician in the lab of neuroanatomist Louis Pierre
Gratiolet, labeler of brain lobes, Pierre tracked
salamanders and frogs in the forests outside Paris.
He was a daydreamer; it was suggested he was perhaps even a bit dim.
PIERRE: "I can't let my head go with every breeze, losing it
to the slightest breath it meets." He began studying Latin and
math, and soon dispelled the early doubts about his intelligence.
By fourteen, he was working to expand the mathematical theory of
determinants into the third dimension. By sixteen Pierre had a
university degree. At twenty-one he published a paper on heat waves.
After joining the Sorbonne's laboratory of mineralogy, he began an
extended study of crystals. He was fascinated by the symmetries he
(16) found in crystalline structures, mirrorings spun out in all directions.

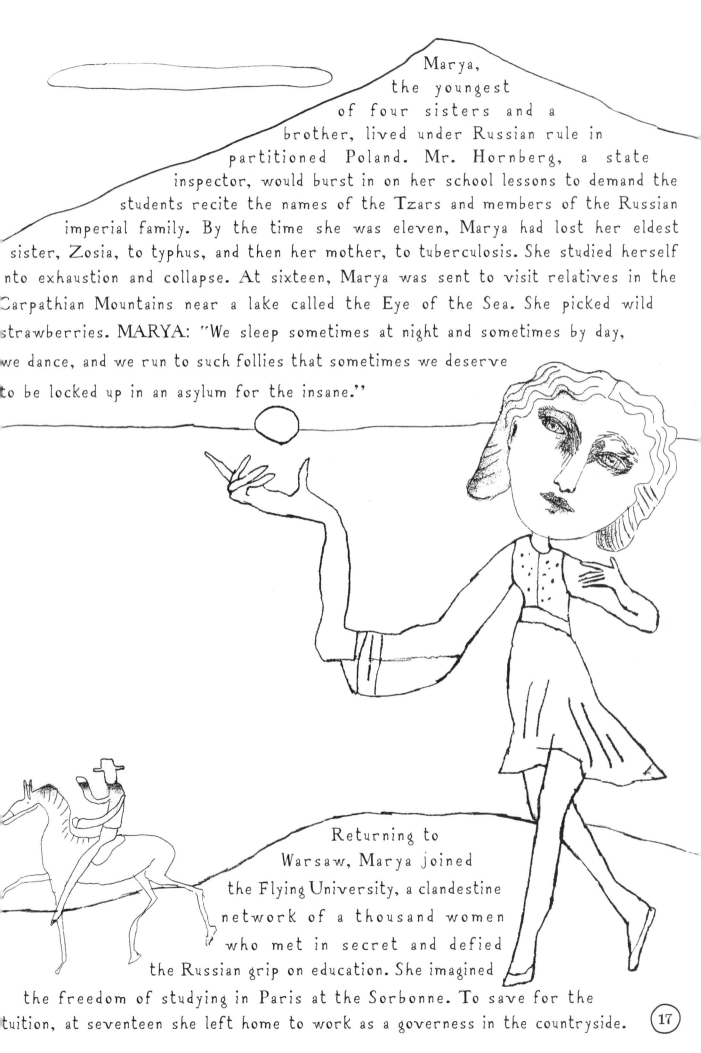

Marya, the youngest of four sisters and a brother, lived under Russian rule in partitioned Poland. Mr. Hornberg, a state inspector, would burst in on her school lessons to demand the students recite the names of the Tzars and members of the Russian imperial family. By the time she was eleven, Marya had lost her eldest sister, Zosia, to typhus, and then her mother, to tuberculosis. She studied herself into exhaustion and collapse. At sixteen, Marya was sent to visit relatives in the Carpathian Mountains near a lake called the Eye of the Sea. She picked wild strawberries. MARYA: "We sleep sometimes at night and sometimes by day, we dance, and we run to such follies that sometimes we deserve to be locked up in an asylum for the insane."

Returning to Warsaw, Marya joined the Flying University, a clandestine network of a thousand women who met in secret and defied the Russian grip on education. She imagined the freedom of studying in Paris at the Sorbonne. To save for the tuition, at seventeen she left home to work as a governess in the countryside.

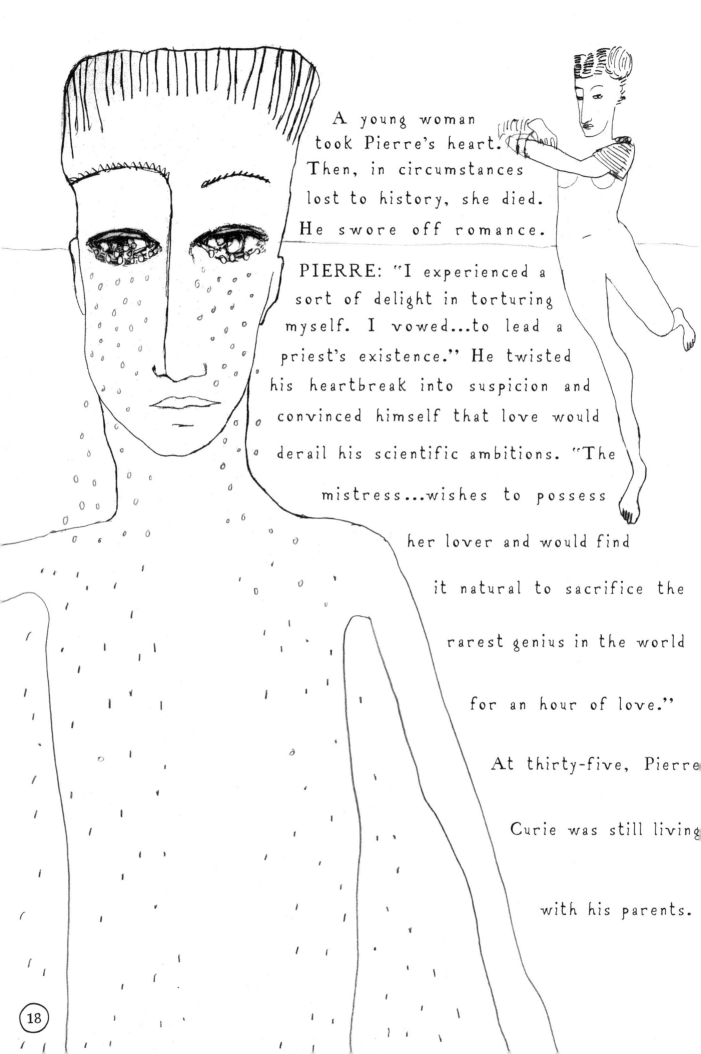

A young woman took Pierre's heart. Then, in circumstances lost to history, she died. He swore off romance.

PIERRE: "I experienced a sort of delight in torturing myself. I vowed...to lead a priest's existence." He twisted his heartbreak into suspicion and convinced himself that love would derail his scientific ambitions. "The mistress...wishes to possess her lover and would find it natural to sacrifice the rarest genius in the world for an hour of love."

At thirty-five, Pierre Curie was still living with his parents.

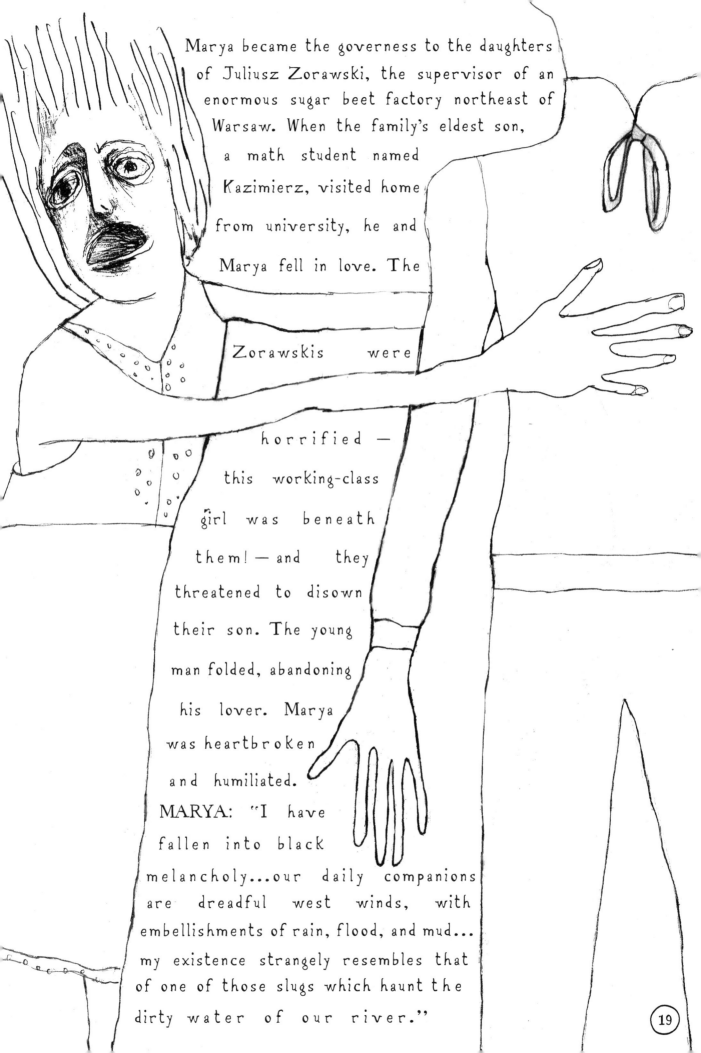

Marya became the governess to the daughters of Juliusz Zorawski, the supervisor of an enormous sugar beet factory northeast of Warsaw. When the family's eldest son, a math student named Kazimierz, visited home from university, he and Marya fell in love. The Zorawskis were horrified — this working-class girl was beneath them! — and they threatened to disown their son. The young man folded, abandoning his lover. Marya was heartbroken and humiliated.

MARYA: "I have fallen into black melancholy...our daily companions are dreadful west winds, with embellishments of rain, flood, and mud... my existence strangely resembles that of one of those slugs which haunt the dirty water of our river."

PIERRE: "I did not regret my nights passed in the woods, and my solitary days. If I had the time I would let myself recount my musings. I would describe my delicious valley, filled with the perfume of aromatic plants, the beautiful mass of foliage, so fresh and so humid, that hung over the Bièvre, the fairy palace with its colonnade of hops, the stony hills, red with heather....

We must eat, drink, sleep, be idle, have

sex, love, touch the sweetest things in life and yet not succumb to them.''

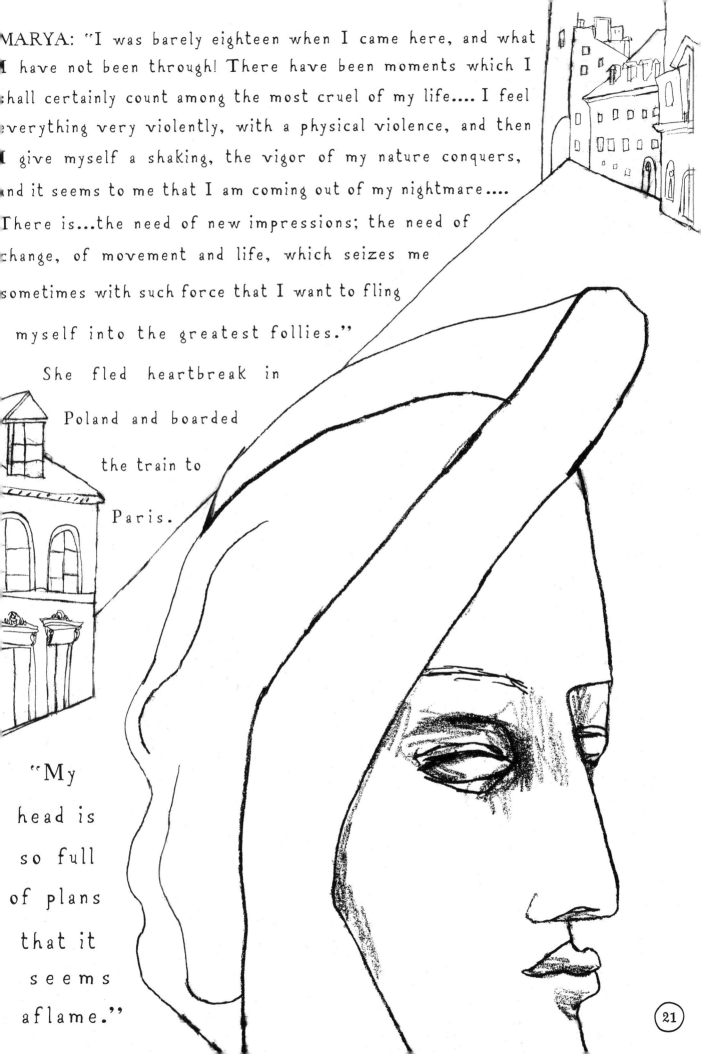

MARYA: "I was barely eighteen when I came here, and what I have not been through! There have been moments which I shall certainly count among the most cruel of my life.... I feel everything very violently, with a physical violence, and then I give myself a shaking, the vigor of my nature conquers, and it seems to me that I am coming out of my nightmare.... There is...the need of new impressions; the need of change, of movement and life, which seizes me sometimes with such force that I want to fling myself into the greatest follies."

She fled heartbreak in Poland and boarded the train to Paris.

"My head is so full of plans that it seems aflame."

21

MAGNETISM

"If a radioactive substance
is placed in the dark in the
vicinity of the closed eye or of
the temple, a sensation of light
fills the eye."

—Marie Curie

For his doctoral thesis, "Magnetic Properties of Bodies at Diverse Temperatures," begun in **1891**, Pierre heated up various materials to feverish temperatures, looking for changes in their powers of attraction.

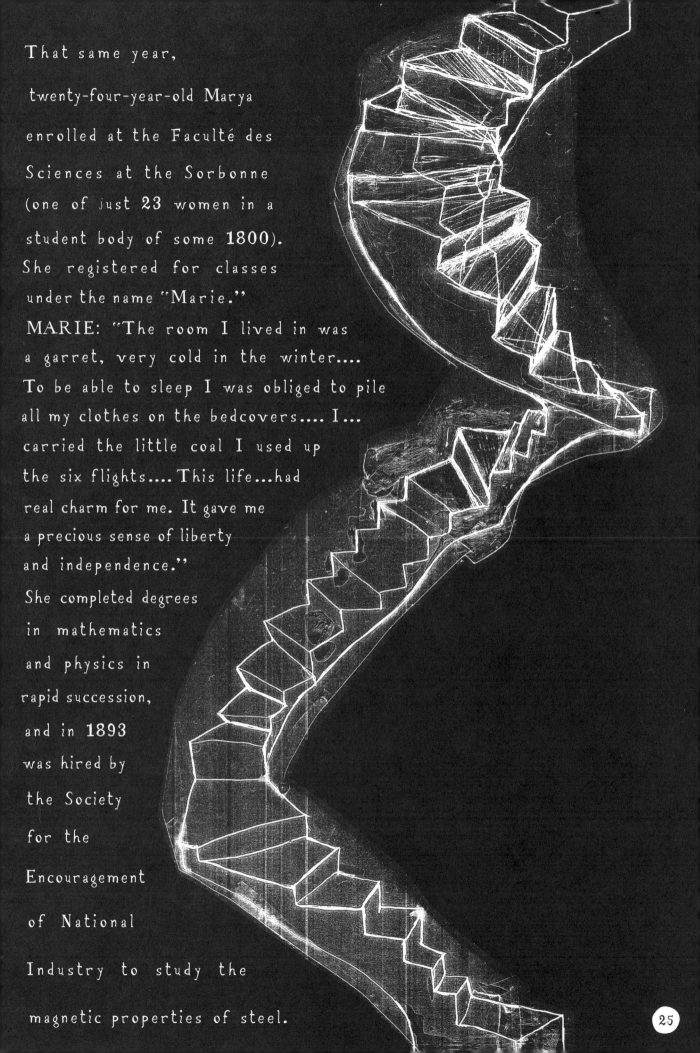

That same year,
twenty-four-year-old Marya
enrolled at the Faculté des
Sciences at the Sorbonne
(one of just **23** women in a
student body of some **1800**).
She registered for classes
under the name "Marie."

MARIE: "The room I lived in was
a garret, very cold in the winter....
To be able to sleep I was obliged to pile
all my clothes on the bedcovers.... I...
carried the little coal I used up
the six flights.... This life...had
real charm for me. It gave me
a precious sense of liberty
and independence."

She completed degrees
in mathematics
and physics in
rapid succession,
and in **1893**
was hired by
the Society
for the
Encouragement
of National

Industry to study the

magnetic properties of steel.

Marie secured space to work in the laboratory of Gabriel Lippmann, a physicist and inventor. Lippmann's *coelostat* was an optical instrument capable of stilling the flickering light of a star and capturing its image on film. For his innovation in color photography — a technique praised for its combination of "stability with colorific splendor" — he would win a Nobel Prize. Yet Lippmann's lab was crowded, and when Marie remarked as much to Polish physicist Józef Kowalski, who was visiting Paris on his honeymoon, he wondered if there might be room in the lab of "a scientist of great merit," the head of the Municipal School of Industrial Physics and Chemistry: Pierre Curie. Kowalski invited them both over for tea.

MARIE: "Upon entering the room I perceived, standing framed by the French window opening on the balcony, a tall young man with auburn hair and large, limpid eyes. I noticed the grave and gentle expression of his face, as well as a certain abandon in his attitude, suggesting the dreamer absorbed in his reflections."

"We began a conversation which soon became friendly."

Pierre Curie studied crystals — quartz, tourmaline, topaz, sugar. Working with his elder brother Jacques, also a physicist, Pierre found that when crystals were pressed along their axis of symmetry, they produced an electric charge. They called this "PIEZOELECTRICITY," from the Greek word *piezein*, meaning "to squeeze."

To provide the precise measurements needed for the work, Pierre created a highly sensitive instrument. Its combination of tiny weights, microscopic meter readers, and pneumatic dampeners would become known as the CURIE SCALE. Pierre's discoveries in the study of magnetism also proved groundbreaking. Heating various materials, some to temperatures of **1400** degrees Celsius (over **2500** degrees Fahrenheit), he concluded that the magnetic properties of a given substance change at a specific temperature. That is, he established a link between heat and magnetism. This temperature is known today as the CURIE POINT. It is used in studying plate tectonics, treating hypothermia, measuring the caffeine in beverages, and understanding extraterrestrial magnetic fields. Mechanisms that depend on piezoelectricity are found today propelling the droplets in inkjet printers, regulating time in quartz watches, controlling the shrill wail of smoke detectors, turning the adjustable lenses of autofocus cameras, acting as the pickups in electric guitars, giving a spark to electric cigarette lighters, reducing vibrations within tennis rackets, and sending out high-frequency audio to monitor the heartbeats of fetuses in medical ultrasound.

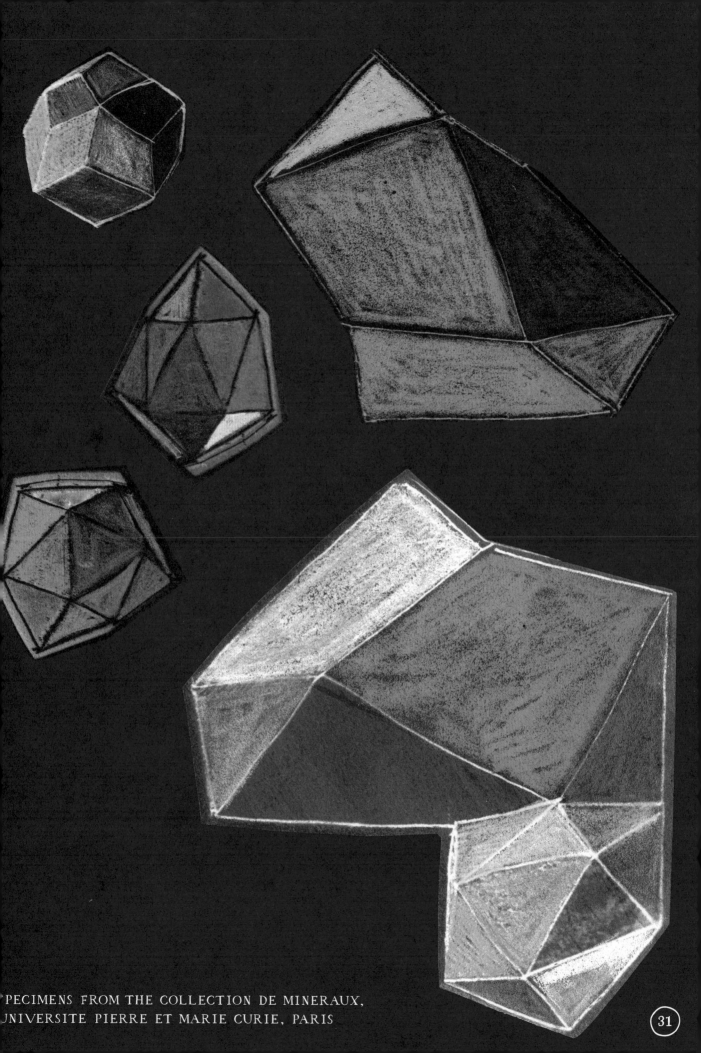

SPECIMENS FROM THE COLLECTION DE MINERAUX,
UNIVERSITE PIERRE ET MARIE CURIE, PARIS

31

Despite the tight quarters in his
lab, Pierre Curie managed to find
room for the delicate and grave
foreign student. He saw a woman who
would not fetter his scientific ambitions but
rather act as collaborator, muse, and guide.
MARIE: "He caught the habit of speaking to me of
his dream of an existence consecrated entirely to scientific
research, and asked me to share that life."
But she had doubts. She longed for her family and for Poland.
Pierre pleaded with her to make her home in France. He
offered friendship, partnership, employment, lodging. He tried guilt.
PIERRE: "What would you think of someone who thought of
butting his head against a stone wall in hope of knocking it over?
...We have promised each other (isn't it true?) to have, for each other, at
least a great affection. As long as you do not change your mind! For there
are no promises which hold; these are things that do not admit of compulsion.
It would, nevertheless, be a fine thing...to pass our lives near each
other, hypnotized by our dreams, your patriotic dream, our humanitarian
dream, and our scientific dream." Finally, he offered to move to Poland.
This gesture dissolved Marie's already fading
misgivings. She wrote to a friend:
"It is a sorrow to me to have to
stay forever in Paris, but
what am I to do? Fate has
made us deeply attached to
each other and we
cannot endure
the idea of
separating."

Marie Skłodowska and Pierre Curie wed on
July 26, 1895. She wore a navy suit and a
blue striped blouse. They took their honeymoon
on bicycles, riding along the coast of Brittany and
into the French countryside, her handlebars
festooned with flowers. These excursions
would become a favorite custom.
MARIE: "The forest of Compiègne
charmed us...with its mass of green
foliage stretching as far as the eye could see,
and its periwinkles and anemones. On the
border of the forest of Fontainbleau,
the banks of the Loing, covered with
water buttercups, were an object of
delight for Pierre.... We loved the
melancholy coasts of Brittany, and
the reaches of heather and gorse,
stretching to the very points
of Finistère, which seemed
like claws or teeth burying
themselves in the water

which forever

rages at them."

CHAPTER 3

FUSION

"Crystals of barium chloride containing
radium are colorless, but when the proportion
of radium becomes greater, they have a
yellow color after some hours, verging on
orange, and sometimes a beautiful pink."

—Marie Curie

Two years and two months into their marriage, Marie gave birth to a six-pound baby girl. They named her Irène.

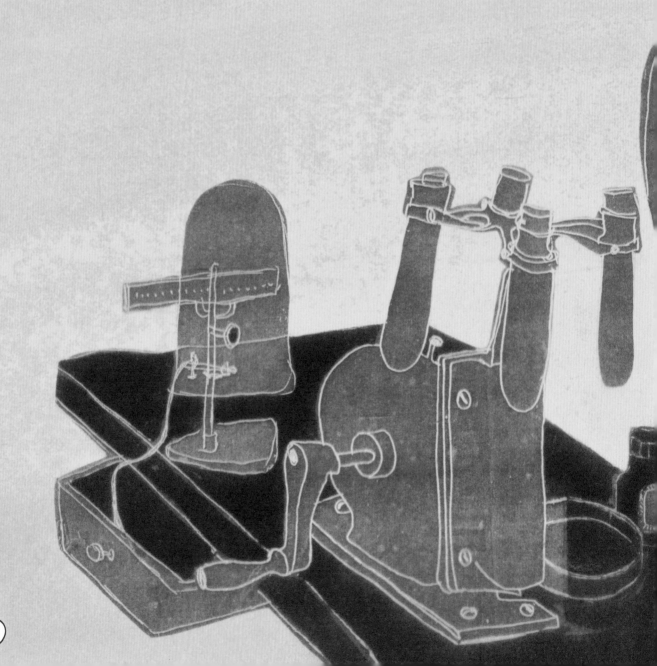

The young couple returned to the lab.

Meanwhile, in Germany, the physicist Wilhem Röntgen was studying high-voltage currents. **During his experiments he noticed that objects in his lab had begun to glow.** Some sort of "invisible light," as he called it, was passing through solid material, lighting it from within. He dubbed the invisible light an "X" ray, X for unknown. On December 22, 1895, Röntgen caught the effect on paper and created the first photograph of a human interior: an X-ray of his wife's fingers and wrist, telescoped to simply bones and a wedding ring. Upon seeing the image (shown right), Anna-Bertha Röntgen exclaimed, "I have seen my own death." Mrs. Röntgen intuited the power of her husband's discovery — to intercept, as well as to hasten, death.

A physicist named Henri Becquerel picked up Röntgen's investigations, exploring the possibility that the fluorescence of the uranium salts he had been working with might be related in some way to Röntgen's X-rays. Becquerel was the third in his family to occupy the physics chair at Paris's natural history museum. His grandfather César Becquerel had studied phosphorescent minerals; his father, Edmond, ultraviolet light. One evening, when an overcast sky prevented him from continuing his day's work, Henri Becquerel tucked his experimental materials away in a desk drawer, leaving a nugget of uranium atop a photographic plate. Opening the drawer days later, he found that the plate appeared to have been exposed to a brilliant light. It was an astonishing discovery, but after publishing his observations, Becquerel did not further pursue them. His work did catch the attention of the Curies, though, and Marie took up the topic as the subject of her doctoral thesis. MARIE: "The question was entirely new." In 1897, darting home midday to nurse her child and cooking for her husband in the evenings, Marie began her research.

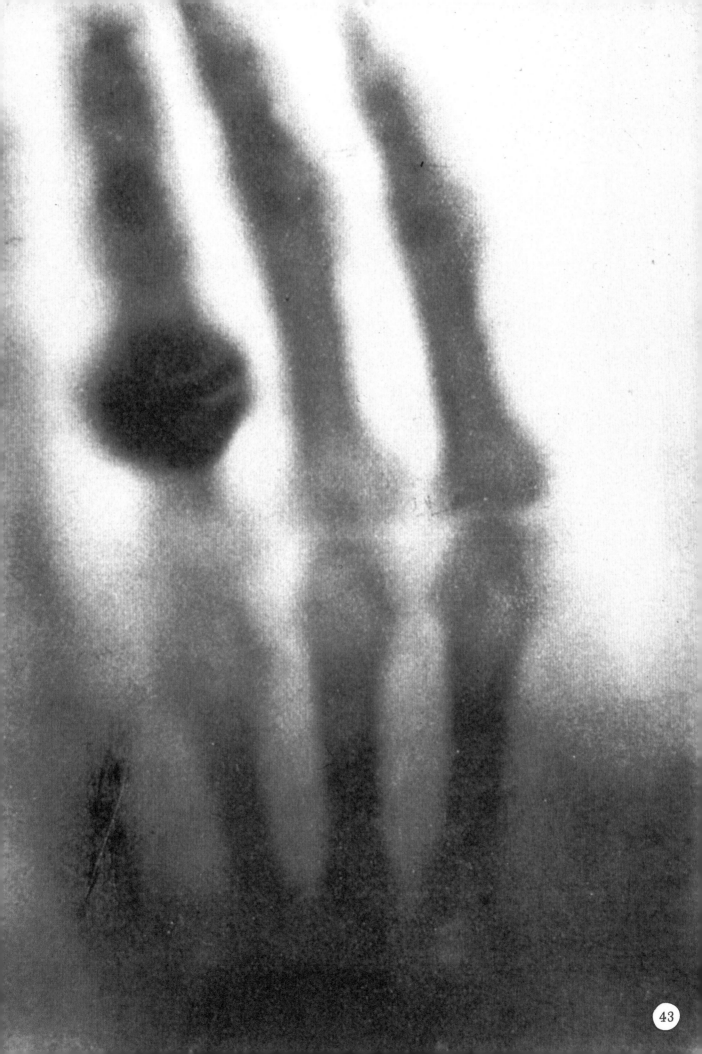

43

For his wife's work, Pierre provided Marie with tools and a technique he had developed with his brother years earlier. An extremely sensitive electrometer measured the electric charge produced by pressure on a crystal. Marie now built a circuit in which a known current would deflect the needle on a dial of an electrometer away from zero. She would then arrange an opposing current, caused by the strange rays, to bring the needle back to zero — the unknown counterbalancing the known. Marie could thus determine the precise intensity of the unknown rays. She hoped the data would coax the unseen into plain view. (When experiments required unconventionally shaped vessels, she learned to blow glass and made them herself.) She was able to establish that the intensity of the rays was not affected by external conditions, that they could not be altered by any chemical process. These rays, she asserted, were a fundamental attribute of the substance in question — they were nothing less than an atomic property of the element. It was a tremendous insight. The very foundation of modern chemistry, Marie could see, was in question: the atom must not be the constant, unchangeable building block of matter scientists had believed it to be. The results raised tantalizing questions that would resonate far beyond the Curies' period.

What was the structure of the atom?

Clearly ENERGY was suspended within it.

Could the energy be harnessed?

To Marie,
"It was obvious that a new science was in the course of development."

This new science needed a name.

MARIE: "I coined the word *radioactivity*."

PART

II

CHAPTER 4
WHITE FLASH

"The compounds of radium are spontaneously luminous. The chloride and bromide, freshly prepared and free from water, emit a light which resembles that of a glow-worm. This light diminishes rapidly in moist air... but ... never completely disappears."

—Marie Curie

Electricity, radio, the telegraph, the X-ray, and now, radioactivity — at the turn of the twentieth century a series of invisible forces were radically transforming daily life. These advances were dazzling and disorienting; for some, they blurred the boundary between science and magic. If invisible light could pass through flesh and expose the human skeleton, was it so fantastical to believe in levitation, in telekinesis, in communication with the dead?

Beginning in the mid-nineteenth century, the Spiritualist movement seduced millions, promising contact with the divine through ghosts and spirits. Now, Spiritualists embraced photography to lend scientific imprimatur to their beliefs, aiming, like Röntgen and Becquerel, to capture in an image what could not be seen with the naked eye. An Austrian named Karl Ludwig Freiherr von Reichenbach presented hazy, geometric shapes documenting a "universal fluid" which he called the "od." Spiritualists claimed that clairvoyants possessed "X-gazes," and that photographic plates placed on the forehead could record vital forces of the brain, or "V-rays."

Spiritualism penetrated
Western culture, low and high. Psychic
detective Sâr Dubnotal, the "Napoleon" of
the Immaterial," was the hero of a series of
anonymously written novels. (His crime-busting
arsenal included hypnotism, magnetism, somnambulism,
autosuggestion and a sexy assistant, Annunciata Gianetti,
who lassoed the voices of the dead with her "spiritual
telegraph.") The movement attracted leading thinkers
and artists, including Alexander Graham Bell, Arthur
Conan Doyle, and Edvard Munch. In Paris, an Italian
medium named Eusapia Palladino drew a circle of
savants and Nobel Prize winners to her Spiritualist
séances: physicists Jean Perrin and Paul Langevin,
mathematician Henri Poincaré, physiologist Charles
Richet, astronomer Camille Flammarion — and Marie
and Pierre Curie.

If the Spiritualist claims proved to be true, Pierre
wrote, there was "nothing more important from a
scientific point of view." He analyzed data from a
séance as he would have in any laboratory experiment.
He measured the ionization of the air. He weighed
Palladino herself, finding that the medium gained six
kilos in the course of the session. He wrote a friend,
"These phenomena that we have seen seem to us
inexplicable by any trickery — tables rising from four
legs, transport of faraway objects, hands that pinch
and caress you, luminous apparitions. Everything in
a place that was prepared by us with participants
we know well and with no possible deception."

Marie supported her husband's Spiritualist explorations but was primarily occupied with her own work in radioactivity. By establishing that radioactivity was an atomic property, she had determined that it could be used to search for new elements. She tested all eighty of the known elements on the periodic table. Only one, thorium, a silver-white metal named for the Norse god of thunder, energized the air as uranium did. She did not stop there. She gathered dozens of other specimens — metals, minerals, salts, and oxides — and pulverized them one by one, each time sprinkling a thin layer of the powdered substance on the lower plate of an ionization chamber. One in particular, pitchblende, yielded results so startling they "seemed abnormal." Pitchblende, a mineral whose samples can look swollen, with dark and shiny welts, was considered a more or less useless byproduct of mining uranium, copper, and cobalt. Colossal amounts of it piled up in the Joachimsthal mines in northwestern Bohemia, where the minerals were used to color pottery and glass. Using Pierre's instruments, Marie determined that pitchblende's radioactivity was significantly more vigorous than that of thorium or uranium — indeed, more powerful than had ever been observed

POLONIUM

in any known substance. Wondering whether she had made an error, she
decided to test a found sample of radioactive ore against a version she
cooked up based on the accepted chemical forumla for the substance. The
fabricated compound was only as radioactive as its uranium content. Yet the
sample weighed the same as the far more radioactive, naturally-occurring ore.
Marie repeated the experiment. Same result. Some mysterious ingredient,
she was beginning to think — microscopic, nameless, and extraordinarily
radioactive — lurked within the naturally occurring specimen.

By establishing that radioactivity was an atomic property, Marie was able to use it
as a tool to search for new elements. The Curies managed to identify a distinct and
previously unknown radioactive element within the pitchblende. Marie named it
"polonium," in honor of her native Poland. Later polonium would be used as a poison,
as a neutralizer of static cling, and as a trigger on nuclear weapons (including
the bomb dropped on Hiroshima). In that summer just before the turn of the
century, however, Marie's discovery offered her a way to honor her homeland.
The discovery of a second unknown ingredient came in December of the same year.
This time they called their new element "radium," from the Latin word for *ray*.

The
Curies had
demonstrated the
existence of polonium
and radium through their
radioactivity. but fellow
scientists remained skeptical. It
was as if the elements had been grasped
only by shadows, and so could be considered
no more definitive than, say, the word of a
Spiritualist medium. Chemists in particular wanted
to see them, to touch them.
Only concrete evidence would be persuasive.
And so, the Curies plunged into a Sisyphean task.
Procuring seven tons of pitchblende — a mountain of
black rubble strewn with pine needles — from the
Bohemian mines, they began trying to extract measurable
amounts of their new elements. They asked the Sorbonne
for laboratory space to complete the work. The university
gave the Curies a dilapidated wooden shed previously used
for human dissection.

MARIE: "It was exhausting work to move the containers about,
to transfer the liquids, and to stir for hours at a time, with an iron
bar, the boiling material in the cast-iron basin. I extracted from the
mineral the radium-bearing barium and this, in the state of chloride, I
submitted it to a fractional crystallization. The radium accumulated
in the least soluble parts, and I believed that this process must lead to the
separation of the chloride of radium. The very delicate operations of the last
crystallizations were exceedingly difficult to carry out in that laboratory,
where it was impossible to find protection from the iron and coal dust."

After four years of steady labor, four hundred tons of water, and forty tons of corrosive chemicals, on March 28, 1902, they managed to extract one tenth of a gram of radium chloride. MARIE: "I shall never be able to express the joy of the untroubled quietness of this atmosphere of research and the excitement of actual progress."

With the constant companionship that accompanied their research, the Curies' love deepened. They cosigned their published findings. Their handwritings intermingle in their notebooks. On the cover of one black canvas laboratory log, the initials "M" and "P" are scripted directly one atop the other.

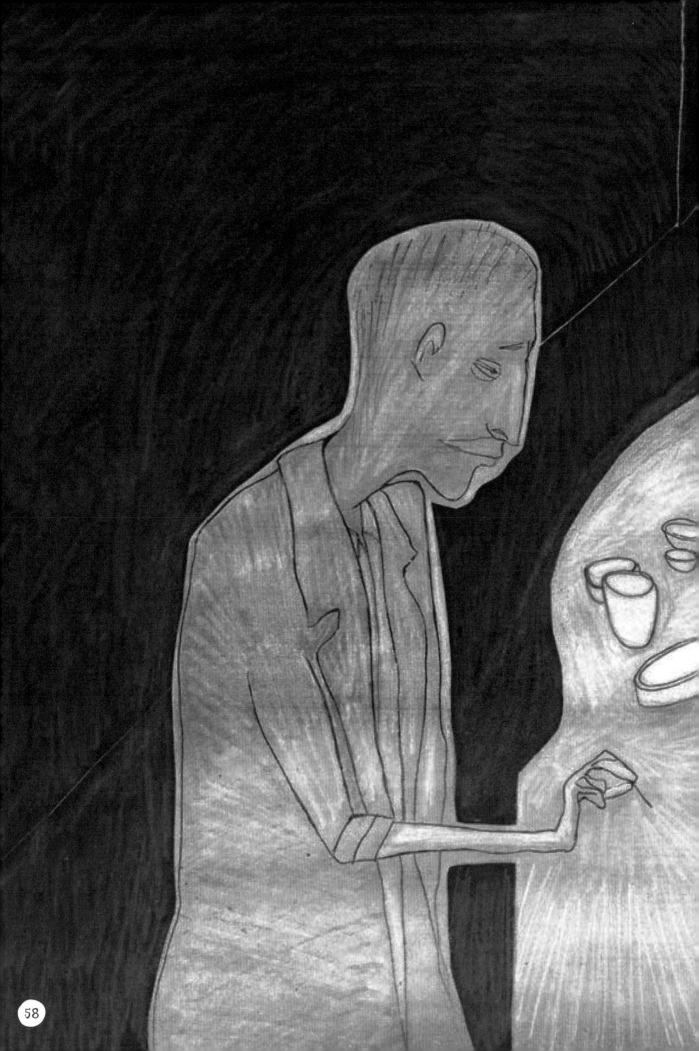

we lived in a preoccupation as complete as that of a dream.

At night, Marie and Pierre lingered in the lab to marvel at the way their samples of radium chloride glowed. MARIE: "These gleamings, which seemed suspended in darkness, stirred us with new emotion and enchantment.... The glowing tubes looked like faint, fairy lights."

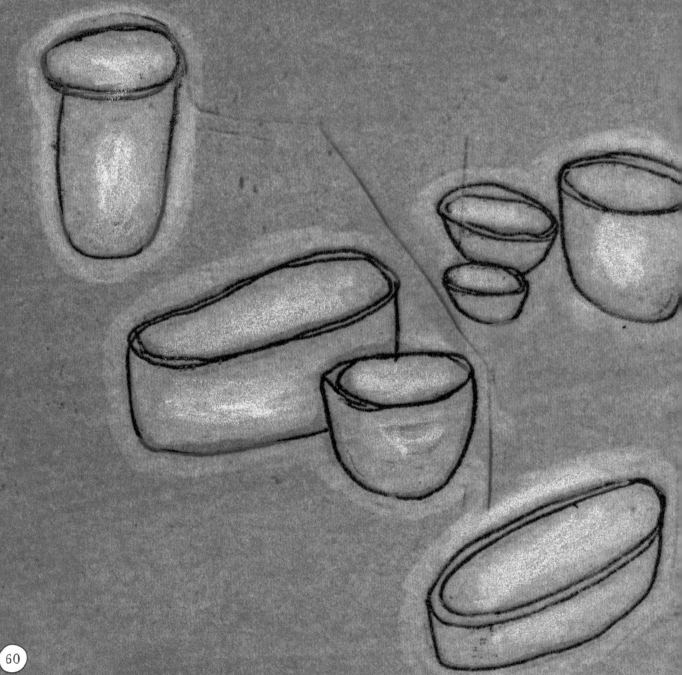

Radium was an instant commercial hit. Yet the Curies chose not to patent their findings. MARIE: "If our discovery has a commercial future, this is an accident." PIERRE: "It would be contrary to the scientific spirit." Others were less principled. Opportunists and charlatans wasted no time in capitalizing on the limited understanding of radium to market it as a wonder drug. There seemed no end to potential applications, some mystical, some practical, many appealing to both impulses at once. Radium, it was said, could cure:

"Anemia, Arteriosclerosis, Arthritis, Asthenia, Diabetes, Epilepsy, General Debility, Gastric Neurosis, Heart Disease, High Blood Pressure, Hyperthyroid, Hysteria, Infection, Kidney Troubles, Muscular Atrophy, Neuralgia, Neurasthenia, Neuritis, Obesity, Prostatitis, Rheumatism, Senility, and Sexual Decline."

A fictitious Dr. Alfred Curie was hatched to shill Tho-Radia face cream. Radium-laced toothpaste, condoms, suppositories, chocolates, pillows, bath salts, and cigarettes were marketed as bestowers of longevity, virility, and an all-over salubrious flush.

Radium was also touted as a replacement for electric lighting. Early electric light was both brilliant and blinding. Robert Louis Stevenson wrote, "Such a light as this should shine only on murders and public crime, or along the corridors of lunatic asylums, a horror to heighten horror." Even after the development of softer, incandescent bulbs, some lamented that electric light would "never allow us to dream the dreams that the light of the living oil lamp conjured up." The fragile glow of radium, on the other hand, offered a retreat into forgiving shadows and candlelit intimacy. Radium let the wistful romantic pose as champion of scientific advance. A chemist named Sabin von Sochocky concocted a luminous goulash of radium and zinc sulphide, with dashes of lead, copper, uranium, manganese, thallium (a neurotoxin discovered by chemist and Spiritualist William Crookes), and arsenic, and sold it to the public as "Undark Paint." Undark was marketed for use on flashlights, doorbells, even "the buckles of bedroom slippers." "The time will doubtless come," von Sochocky declared, "when you will have in your own house a room lighted entirely by radium. The light thrown off by radium paint on walls and ceilings would in color and tone be like soft moonlight."

Dancer Loïe Fuller had dreamed of creating just such a beguiling illusion in her performances. A master of manipulating colored light and billowing fabric, Fuller was known at the Folies Bergère and beyond as the human incarnation of Art Nouveau's winding tendrils and shimmering palette. Her dances — including a Serpentine Dance, a Lily of the Nile dance, and a hellfire scene in one production of *The Damnation of Faust* — made use of improvised movement and shifting light. With the help of Thomas Edison, she conducted experiments using phosphorescent salts. In a notebook she scrawled a feverish description of her trips to Edison's lab: "We made a dress and a veil out of black gauze and spotted it with calcium. When the veil was thrown up into the air, it disappeared in the darkness and only the falling luminous drops were seen elongated in their descent taking on the form of great violet blue tears. The dress in movement produced the same effect, and I was told that I seemed to be far back and away from the falling tears, the black gauze of the dress being invisible. And I myself seemed to be a black silhouette figure. We made huge green and gold butterflies with red spots on their backs. And green serpents. These things looked ethereal, spiritual, and made me feel in touch with the supernatural." But these marvelous effects had only whetted her appetite. Loïe wanted to glow in the dark. When she contacted the Curies, however, they turned down her request to turn their scarce and costly prize into the "butterfly wings of radium" costume she envisioned. Nevertheless, a moth to the Curies' flame, Loïe Fuller came to dance in their home.

Marie Curie had named her first element polonium to bring attention to her homeland but was disappointed to find it overshadowed by her second discovery, radium. We pause here to grant Marie's original wish. Here is a select array of luminaries, flora and fauna from the land known today as Poland:

Frédéric Chopin (1810–1849), composer, pianist. (Hand cast, Bibliothèque Polonaise, Paris.)

CASIMIR FUNK (1884–1967), biochemist; credited with first understanding of vitamins.
JOSEPH CONRAD (1857–1924), novelist.
JOSEPH ROTBLAT (1908–2005), physicist, only scientist to resign from the Manhattan Project once it was understood, in 1944, that there was to be no German atomic weapon, winner of the Nobel Peace Prize, 1995.
CZESŁAW MIŁOSZ (1911–2004), poet, writer, Nobel Prize for Literature, 1980.
STANISŁAW LEM (1921–2006), philosopher, writer of science fiction novels including *Solaris*; asteroid 3836 Lem is named in his honor.
RYSZARD KAPUŚCIŃSKI (1932–2007), journalist and writer.
ADAM MICKIEWICZ (1798–1855), Romantic poet.

LECH WAŁĘSA (born 1943), car mechanic, electrician, father of eight, co-founder of the Solidarity movement, winner of the Nobel Peace Prize, president of Poland (1990–1995).
HENRYCK ARCTOWSKI (1871–1958), explorer of the Antarctic; the phenomenon of a rainbow-like halo, created as light around the sun passes through ice crystals, bears his name.
BIURO SZYFRÓW: The Polish Cipher Bureau; broke the German Enigma code.
ELIE NADELMAN (1882–1946), artist, sculptor whose work includes delicate carvings of dancing couples as well as the colossal figures in the lobby of the New York State Theater at Lincoln Center.

CHYKA GROSSMAN (1919–1996), a leader in the Polish underground in World War II, active in ghetto uprisings; later, Zionist leader and member of the Israeli Knesset.
TEODOR TALOWSKI (1857–1910), architect known for asymmetrical buildings with whimsical ornament (a singing frog, a spider and a sundial, a crying mule), and Latin inscriptions (e.g., Festina lente — hurry slowly).

DAVID BEN-GURION (1886–1973), first prime
minister of Israel.

KRYSTYNA CHOJNOWSKA-LISKIEWICZ
(born 1936), first woman to
sail solo around the world,
traveling 31,166 nautical
miles in 401 days.

HALINA KONOPACKA (1900–
1989), winner of Poland's first
Olympic gold medal (for the
discus throw) during the 1928
games in Amsterdam.

LUCYNA ĆWIERCZAKIEWICZOWA
(1829–1901), writer; author of the first
Polish cookbook, *Jedyne Praktyczne Przepisy
Wszelkich Zapasów Spizarnianych Oraz Pieczenia
Ciast* (The Only Practical Compendium of Recipes for All
Household Stocks and Pastry), 1858.

MORDECHAJ ANIELEWICZ (1919–1943), commander
of the Żydowska Organizacja Bojowa (Jewish Fighting
Organization) during the Warsaw Ghetto Uprising.

ISAAC BASHEVIS SINGER (1902 or 1904–1991),
writer, champion of Yiddish literature, vegetarian,
winner of the Nobel Prize for Literature, 1978.

COUNT JAN NEPOMUCEN POTOCKI (1761–1815),
Egyptologist, first Pole to fly in a hot air balloon, 1790.

TAMARA DE LEMPICKA (1898–1980),
glamorous, bisexual Art Deco painter of heavy-lidded
women with red lips and marble-smooth curves
enfolded in satin.

DANIEL LIBESKIND (born 1946), child accordion
virtuoso, architect.

ARTHUR RUBINSTEIN (1887–1982), pianist.

MAREK EDELMAN (1922–2009), cardiologist,
political and social activist, one of the leaders of
the Warsaw Ghetto Uprising.

JAN KARSKI (1914–2000), World War II resistance
fighter; played critical role in informing the West
of plight of Polish Jewry in Warsaw Ghetto and
extermination camps.

WISŁAWA SZYMBORSKA (born 1923), poet, essayist,
translator, winner of the Nobel Prize in Literature, 1996.

BRONISŁAW MALINOWSKI (1884–1942),
anthropologist, author of *Argonauts of the Western
Pacific*, *The Sexual Life of Savages in North-Western
Melanesia*, and *Coral Gardens and Their Magic*.

NICOLAUS COPERNICUS (1473–1543), astronomer; developed heliocentric model of the universe.

ZYGMUNT BAUMAN (born 1925), philosopher, coined
term "Liquid Modernity."

LESZEK KOŁAKOWSKI (1927–2009),
philosopher, critic of Marxism.

POPE JOHN PAUL II (Karol
Józef Wojtyła) (1920–2005),
Pope and Sovereign of the
State of the Vatican City
from October 16, 1978,
until his death; the first non-
Italian Pope since the 1520s;
his was the second-longest
pontificate in history.

VLADEK SPEIGELMAN:
Auschwitz prisoner and survivor
175113, father of Art Spiegelman,
protagonist of Speigelman's graphic novel *Maus*.

JAN ŁUKASIEWICZ (1878–1956), mathematician.

TADEUSZ KOŚCIUSZKO (1746–1817), military leader,
hero in uprising against Imperial Russia, colonel in
American Revolution, emancipator of American slaves.

ANTONI NORBERT PATEK (1811–1877), watchmaker,
founder of Patek Philippe & Co., creators of the nine-
hundred-part Supercomplication pocket watch (1933),
which garnered the highest price on record for a watch
sold at auction, in 1999 ($11 million).

SAMUEL ORGELBRAND (1810–1868), publisher
of the first modern Polish-language encyclopedia,
Encyklopedia Powszechna.

NATHAN HANDWERKER (1892–1974), founder of
Nathan's Famous, the hot dog company.

ANDRZEJ WAJDA (born 1926), film director, winner
of the Palme d'Or at Cannes for *Man of Iron*, about
the Solidarity movement, 1981.

HELENA MODRZEJEWSKA (1840–1909), Shakespearean
actress, cofounder of a utopian colony in California, 1876;
the inspiration for Susan Sontag's novel *In America*.

FLORA

SILVER THISTLE (silver-white, spiny-petalled)

GREAT SUNDEW (insect-trapping, tentacled)

TOADFLAX (caramel-colored, snapdragon-like)

FAUNA

WILD GROUSE (varied vocalizations, conspicuous preening)

WILD BOAR (nocturnal foragers)

MARMOTS (highly social, good whistlers)

EUROPEAN BISON (nocturnal, solitary)

CHAPTER 5

INSTABILITY OF MATTER

"If a celluloid or thin india rubber capsule containing a very active salt of radium is placed on the skin, and left for some time, a redness is produced upon the skin ... a local change in the skin appears and acts like a burn. In certain cases a blister is formed. If the exposure was long in duration, an ulceration is produced which is long in healing."

—Marie Curie

"It could even be thought that radium could become very dangerous in criminal hands, and here the question can be raised whether mankind benefits from knowing the secrets of Nature, whether to profit from it or whether this knowledge will not be harmful for it. The example of the discoveries of Nobel is characteristic, as powerful explosives have enabled man to do wonderful work. They are also a means of terrible destruction in the hands of great criminals who are leading the people to war."

—Pierre Curie, 1903

In 1900 Pierre strapped a tube of radium against his arm for ten hours. "To his joy, a lesion appeared," reported his daughter Eve. He examined the damage with detachment.

PIERRE: "On the 42nd day, the epidermis began to reform around the edges of the wound, approaching the center, and 52 days after the action of the rays, there is still an injury of one centimeter square with a grayish aspect indicating a deeper injury."

The implications were spine-tingling. If radium destroyed healthy tissue, could it also destroy diseased tissue? That is, could radium cure cancer? To find out, the Curies began experimenting on mice, guinea pigs, and rabbits. Treatment on people, called *curiethérapie*, soon followed, with radiation sources inserted into the body or strapped to its surface. In the century since, while improvements in delivery, targeting, and control of radiation levels have been made, the basic premise that radiation can be used to inhibit malignant growth remains unchanged.

70 CURIETHERAPY TREATMENT CIRCA 1920

In August 2001 Daniel Fass was a high school student on summer vacation in Rhode Island with his parents and older sister when he began feeling ill.

DANIEL FASS: "I couldn't breathe. I couldn't begin to inhale. The next day, the center of my rib cage looked a little bit bruised. We thought, maybe it's Lyme disease, we'll just keep an eye on that. But it didn't go away and it ached a little bit. We went to the little medical center on Block Island. They took a quick X-ray of my chest and it looked like my heart was bigger than it should have been.

"I got a CAT scan. There was a massive tumor next to my heart and lungs. Non-Hodgkins lymphoma. It was August 1, 2001. I was fourteen. Obviously I thought, 'Well, am I going to die?'

"The tumor increased its mass 50 percent in twelve hours. I started cranial radiation. I'd lay on a metal table. They created a face mask of smooth, flat mesh to hold my head in place. They made it soft and then let it fold down across the face, my entire head, part of the neck. I don't remember if I had hair at that point. Once it stretched it hardened. It had a sort of frame — like a picture frame, with four holes, so they could put screws in to make sure it was in the same exact position each time. It was secured to the table, underneath the radiation machine.

"The machine is lined up, pointing down at you, and the door slowly seals itself. They talk to you through some kind of radio, and say, 'hold your breath' or something. You hear a buzzing sound.

"At the end we were able to keep the mask. We put it in the basement. My mom and dad and sister say they can see my face in it. But I just see right through it — you know how with those Magic Eye 3-D images you look at? Some people see it and some people can't see it at all? I don't see my face in it."

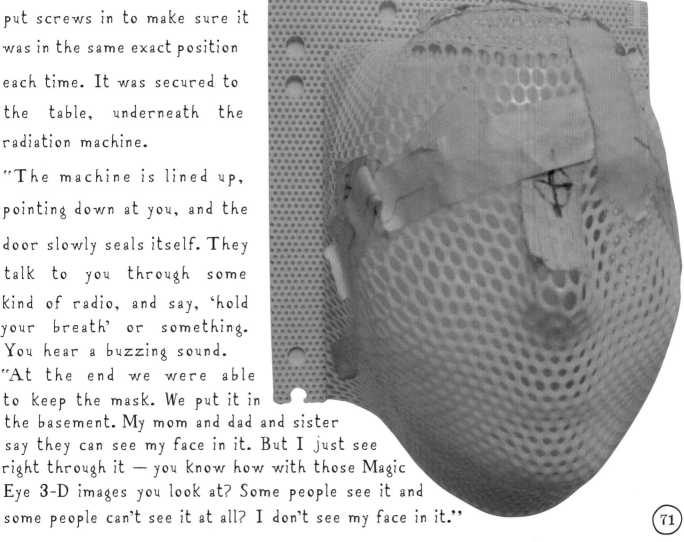

THERMOPLASTIC RADIATION MASK 2001

On June 25, 1903, Marie defended her thesis "Researches on Radioactive Substances," and became the first woman in France to receive a doctorate. Her former advisor, color photography pioneer Gabriel Lippmann, presided over the examination committee in a tuxedo, along with physicist Edmond Bouty and Henri Moissan, a synthesizer of microscopic diamonds. Marie's students were present, as were a number who followed in her husband's footsteps — including protégé Paul Langevin, who had received his doctorate from Pierre Curie the previous year. Later that night, Langevin, Jean Perrin, his wife, Henriette, and newlyweds Ernest Rutherford and Mary Newton joined the Curies for dinner. In the postprandial languor, like a sorcerer or a prophet, Pierre unveiled a small cylinder of radium for his guests.

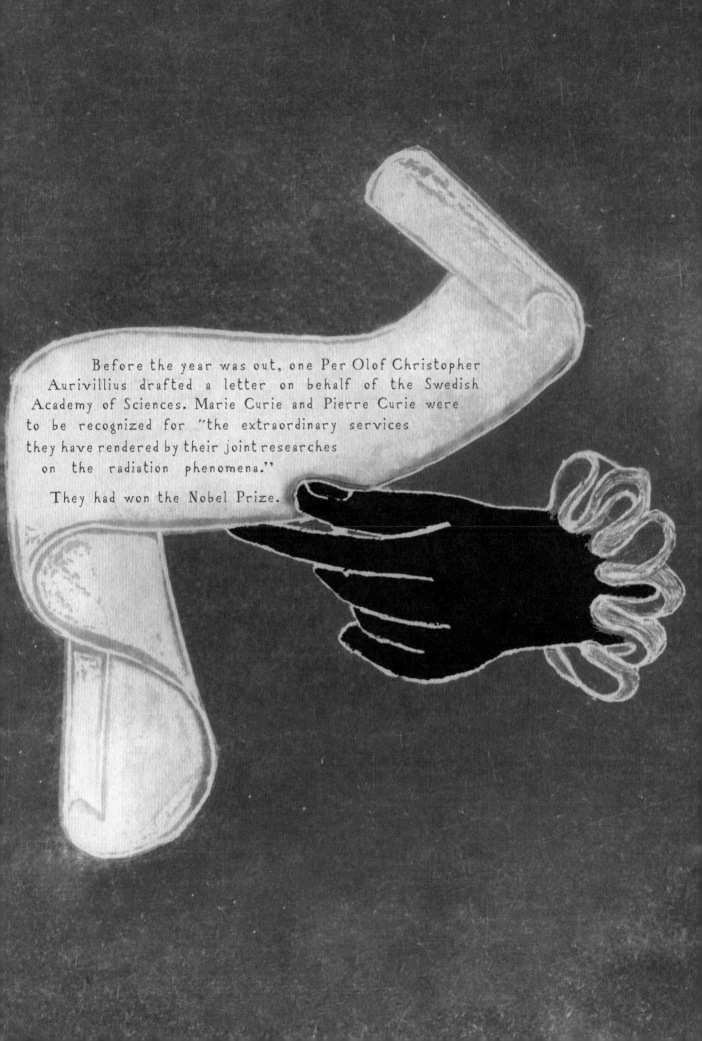

Before the year was out, one Per Olof Christopher
Aurivillius drafted a letter on behalf of the Swedish
Academy of Sciences. Marie Curie and Pierre Curie were
to be recognized for "the extraordinary services
they have rendered by their joint researches
on the radiation phenomena."

They had won the Nobel Prize.

Marie was too ill to travel to Stockholm to accept the award. Over the summer she had suffered a miscarriage. MARIE: "I had grown so accustomed to the idea of the child that I am absolutely desperate and cannot be consoled." Her husband was barely the stronger. PIERRE: "I am neither very well, nor very ill.... I am easily fatigued, and I have left only a very feeble capacity for work." He resigned his post at the School of Physics. (Langevin took the position.) Just as the press seized the couple's story to shape into a fairy tale — newspaper articles beginning their stories "Once upon a time..." — just as the world showered them with acclaim and riches — just, that is, as they should have been most formidable, the Curies faltered. The powers of radium with which they were so enamored — Marie had taken to sleeping with a little jar by her pillow — were steadily corroding their bones, straining their breathing, burning their skin. Their entire lab was toxic. MARIE: "Dust, the air of the room, and one's clothes, all become radioactive. The air in the room is a conductor.... We can no longer have any apparatus completely isolated." Radioactivity had made the Curies immortal. Now it was killing them.

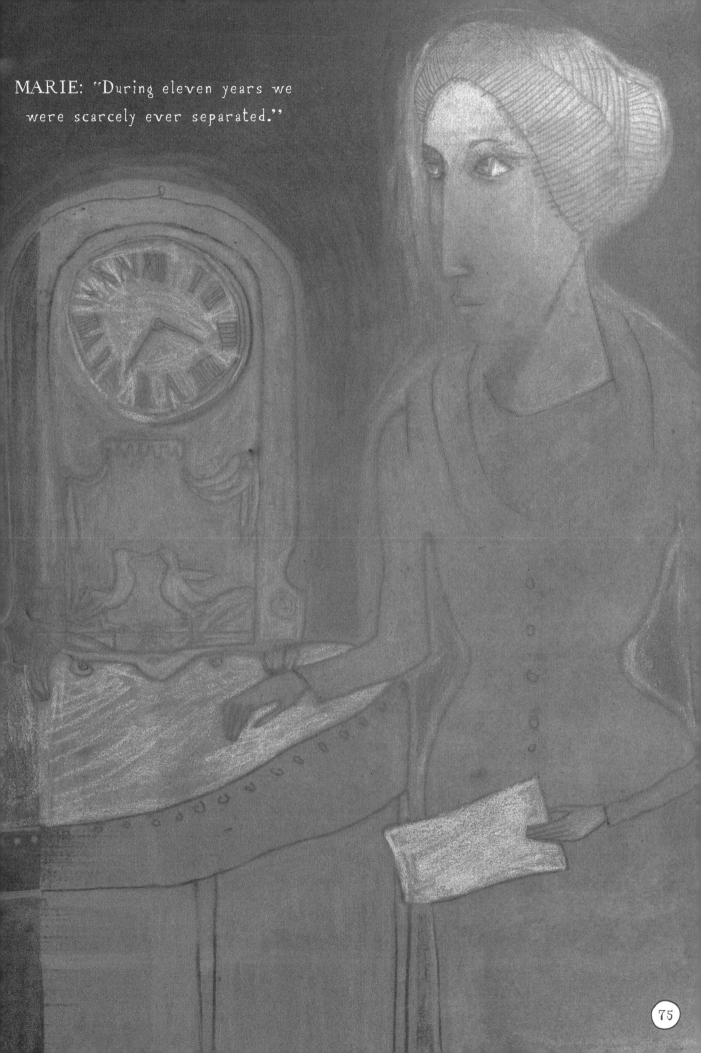

MARIE: "During eleven years we were scarcely ever separated."

After a summer's rest and a holiday in the countryside, Marie's health had improved. On December 6, 1904, she gave birth to a second daughter.

They called her Eve.

MARIE

"I have been frequently questioned, especially by women, how I could reconcile family life with a scientific career. Well, it has not been easy."

MARIE

That same year, in New York City, Ella Oppenheimer, a pretty, slender painter with a congenitally disfigured right hand, and her husband, Julius, a lanky importer of textiles, also had a child. Their blue-eyed son would grow up to love poetry and literature, and to make his name as a physicist. Today, we know J. Robert Oppenheimer as the "father of the atomic bomb." From 1942 to 1945, at a cost of $2.2 billion and employing some 130,000 people, the United States raced to develop the world's first nuclear weapon. The operation was code-named the Manhattan Engineer District, or, more commonly, the "Manhattan Project." Oppenheimer was the project's scientific director.

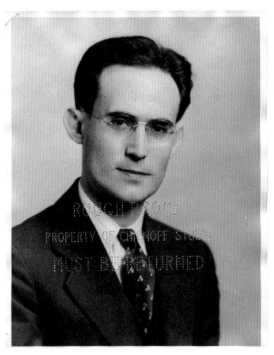

IRVING S. LOWEN

was a theoretical physicist at the Metallurgical Laboratory, or MetLab, on the Chicago branch of the Manhattan Project, where he designed nuclear reactors for the production of plutonium. Along with many of the scientists, he feared that Allied efforts to build an atomic weapon were lagging behind those of the Nazis. In a break with project secrecy, he brought his message to President Franklin D. Roosevelt. His subsequent fate has left questions in the mind of his descendants, including his granddaughter, Cynthia Lowen, a poet in New York City. Historian Joseph Lash wrote of the incident in his book on the Roosevelts, *Eleanor and Franklin*, based on Eleanor's private papers.

CYNTHIA LOWEN: "My grandfather was goaded into a sacrificial mission. In 1943 a message came that the Germans were close to developing an atomic weapon. The scientists were very concerned. They sort of drew straws to see who would go to Eleanor Roosevelt to pressure the president to have the military build the reactors faster. Irving was chosen. They met at her Washington Square apartment. She called the president shortly after. Then she sent a letter."

ELEANOR ROOSEVELT TO FRANKLIN ROOSEVELT: "Mr. Irving S. Lowen, the man whom I telephoned about will be in Washington tomorrow....There is, they believe, a chance that a very brilliant man who is working on this in Germany may have been able to develop it to the point of usefulness. The Germans are desperate and would use this if they have it ready. It is imperative they feel we proceed quickly to perfecting it and these young scientists believe that they are already two years behind.... I hope you will see Lowen. He impresses me with his own anxiety."

CYNTHIA LOWEN: "He met with FDR the next day. That was July of 1943. And he went back to the White House in the fall. On that occasion he didn't meet with the president but he met with some of the president's staff. They thought he was out of his mind. Evidently he was looking in closets."

JOSEPH LASH: "'Is your room tapped?' was the scientist's first remark.... Then Lowen darted over to a closed door and threw it open to see if anyone was listening at the keyhole. Reassured that all was secure in the White House, he told them about the A-bomb project and the fears of scientists that the project was moving slowly because of military red tape."

CYNTHIA LOWEN: "People were pissed. General Leslie Groves, who was in charge of the Manhattan Project for the army, was pissed. Vannevar Bush, head of the National Defense Research Committee, was pissed. A.H. Compton, a top theorist on the project, was pissed."

FRANKLIN ROOSEVELT TO VANNEVAR BUSH: "This young man has bothered us twice before...I fear...that he talks too much."

CYNTHIA LOWEN: "He was kicked off the project. His career was over. He went to work on cosmic rays for the Navy. Then he died suddenly of internal hemorrhaging, just shy of his thirty-ninth birthday. That was never explained."

SECRET PERSONAL AND CONFIDENTIAL

Mar. 19, 1944

SAC, New York City

100-198625-762

J. Edgar Hoover - Director, Federal Bureau of Investigation

FOLPA 248235

Lieutenant Colonel John Lansdale, Jr. has furnished the following information concerning Irving S. Lowen.

"Subject was employed on June 1, 1943 by the Metallurgical Laboratory, University of Chicago, as a Research Assistant in Dr. Wigner's Section. When he was employed, Subject signed a statement indicating that he had read Sections 31 through 42 of the Espionage Act and that he held himself responsible for conduct in accordance with the provisions thereof. He also signed a sworn statement under oath not to divulge or disclose any secret or confidential information that he might obtain or acquire by reason of his connection with the Metallurgical Laboratory, University of Chicago, unless authorized to do so by the Director or a Member of that Laboratory.

"Subject was employed on a temporary basis for the summer months. He was not continued in a permanent capacity with the Laboratory and was relieved from his duties September 1, 1943. It is reported that he has returned to New York City and is presently residing at 925 Prospect Place, Brooklyn, New York, and is employed by the New York University, Physics Department.

"In July, 1943, while Subject was employed at the Metallurgical Laboratory, there was a certain amount of dissatisfaction in the Section in which he was employed, springing out of a dislike for the way the Project as a whole was being handled. The individuals expressing this dissatisfaction indicated that they would have preferred to have run the entire Project themselves without bringing in either the Army or private contractors.

"A highly confidential and reliable source indicates that Subject has made two trips to Washington, D. C., in order to put his complaint before the President of the United States. Certain facts about Subject's first trip to Washington, are known. Upon leaving Chicago, he went first to New York City, his home. Subject checked in at the Bellevue Hotel in Washington, D. C., at 3:20 P. M., July 28, 1943. He had no baggage and paid in advance for Room 440, to which he was assigned. He checked out at 4:55 P. M., July 29, 1943. Some time on July 28, Subject made a telephone call from his Hotel to the University of Chicago, talking for ten minutes. Also on July 28, a person-to-person call was made to Subject at the Bellevue Hotel from a Chicago number, Hyde Park 9721, listed in the name of Eugene Wigner. There is a possibility that Subject did not leave Washington immediately after checking out of the Bellevue, or that he left and returned later, since a Western Union Telegram was delivered for him in care of the National Research Council, 1530 P Street, N. W., on July 30, 1943, at 10:16 P. M.

"Apparently at this time, Subject's chief objection was to the Army and its management of the Project. Subject had originally intended someone higher in the Project to consult with the President. However, he found that the appointment had already been made for him to see the President. Without consulting his colleagues, he went ahead and saw the President a few minutes and stated his grievances. The President told him to go to see either Dr. Vannevar Bush or Dr. James Conant. Subject saw Dr. Conant who told him to see Dr. A. H. Compton."

MAILED

JUN 27

78

"One confidential informant believes that the arrangements for Subject's interview were made by Mrs. Roosevelt. It is not known how arrangements were made for Subject to meet Mrs. Roosevelt. Another informant has presumed that Subject has a personal friend on the White House Staff. (S)(W)

"Subject made a second trip to Washington, D. C., in order to visit the White House. The exact date of this visit is not known, but it is believed that it occurred subsequent to September 1, 1943, when Subject's employment was terminated.(S)(W)

"Confidential Informant states that Subject had become alarmed at the German reports concerning a secret weapon and the progress they were making with it, and that Subject had made a formal request to discuss with the President the delay in the accomplishments of the Project. It is reported that the President was out of the country at the time and that Mrs. Roosevelt asked Subject to come to the White House and discuss his complaints with the White House Staff. Subject is reported to have stayed in Washington, D. C., three days and to have spoken with Secretary Early, unnamed members of the President's Staff, Dr. Bernard Baruch, and Dr. Conant. It is reported that the President's Staff came to the conclusion that Subject was at least slightly crazy; but nevertheless, they were disturbed over his complaints.(S)(W)

"Apparently on the second trip, Subject's complaints were two-fold. His first complaint was that the Project had made a mistake in not continuing the P-9 Program as planned last summer. The second complaint was that it was a mistake to place responsibility for the successful completion of the Project in the hands of certain scientists and not to give this responsibility to others of the scientists.(S)(W)

"The abandonment of the P-9 Program, referred to above, occurred subsequent to the date of Subject's release from employment on the Project.(S)(W)

"Information concerning Subject's background is as follows: He was born 20 December 1910 in New York City; his father, Morris Lowen, was born in Germany and is a U. S. Citizen; his mother, Bertha Weisberg, was born in Russia and is a U. S. Citizen; he has one married sister, Blanch Grodzicker, born in the United States, presently residing at the family residence, 925 Prospect Place, Brooklyn, New York. Subject graduated from City College of New York, 1931, with B. A. degree in Physics; he attended Columbia University in Michigan in 1932 where he studied Physics; from 1932 to 1934 he attended New York University where he received a Ph. D. in Physics. Subject was employed by the Physics Department in New York City University, 1935 - 1942; and from 1942 to 1943, he was employed by the U. S. Navy at the Brooklyn Navy Yard.(S)(W)

"The facts related above as they were developed by this office apparently concerned only an administrative matter until it was found that Subject was in possession of and communicating information relating to the DSM Project which existed only after his severance from the Project. This office is interested in determining from whom Subject received this information and also whether Subject is continuing to receive information concerning progress of the Project."(S)(W)(S)

 The New York Office should ████████████ on the subject and generally determine his present activities and contacts.

cc Chicago
cc San Francisco

b7E

The Americans succeeded in building the world's first atomic weapon. The uranium-235, fission
device was detonated **1900** feet above Hiroshima, Japan, at **8:15** on the morning of August 6, **1945.**

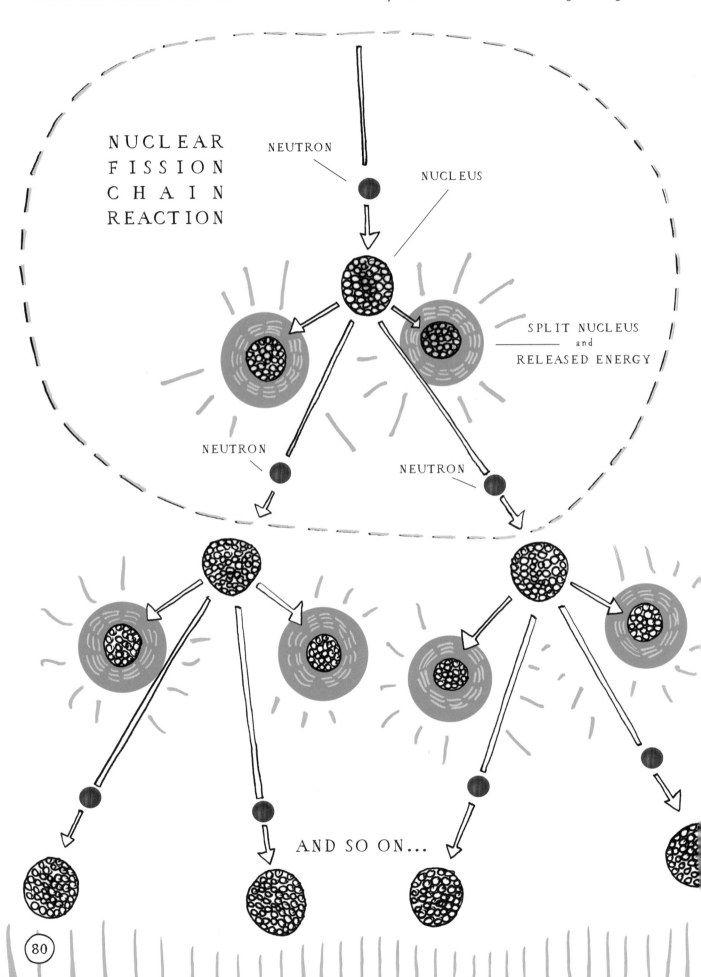

NUCLEAR
FISSION
CHAIN
REACTION

NEUTRON

NUCLEUS

SPLIT NUCLEUS
and
RELEASED ENERGY

NEUTRON

NEUTRON

AND SO ON...

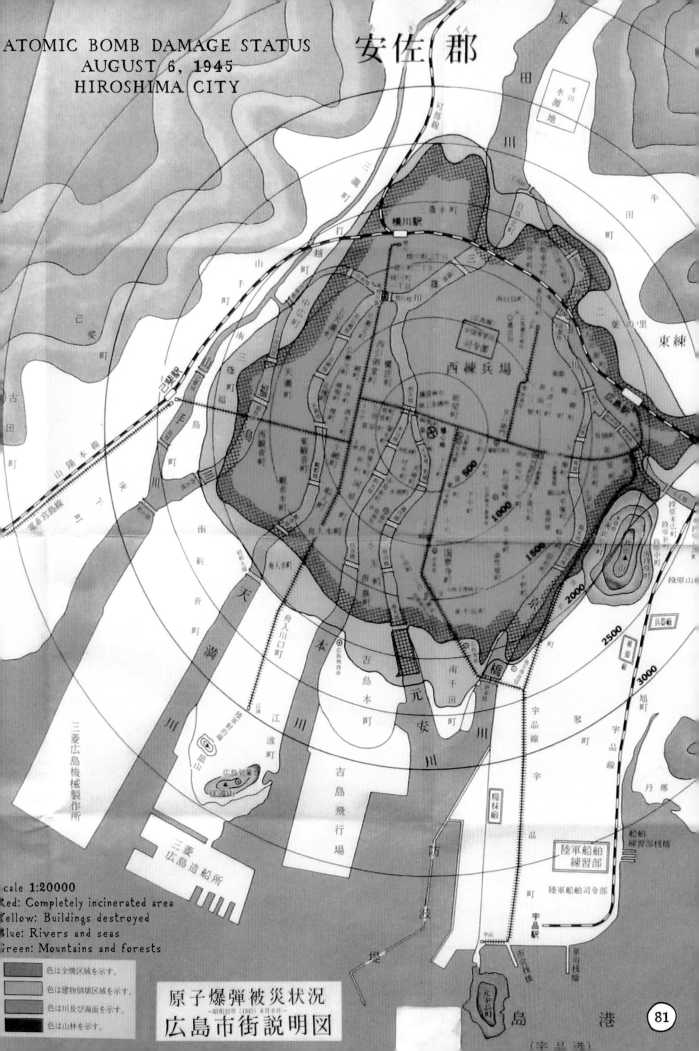

ATOMIC BOMB DAMAGE STATUS
AUGUST 6, 1945
HIROSHIMA CITY

Scale 1:20000
Red: Completely incinerated area
Yellow: Buildings destroyed
Blue: Rivers and seas
Green: Mountains and forests

安佐郡

色は全焼区域を示す。
色は建物倒壊区域を示す。
色は川及び海面を示す。
色は山林を示す。

原子爆弾被災状況
—昭和20年（1945）8月6日—
広島市街説明図

81

笠岡 貞江

SADAE KASAOKA

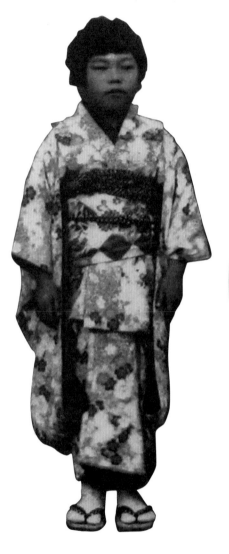

1945

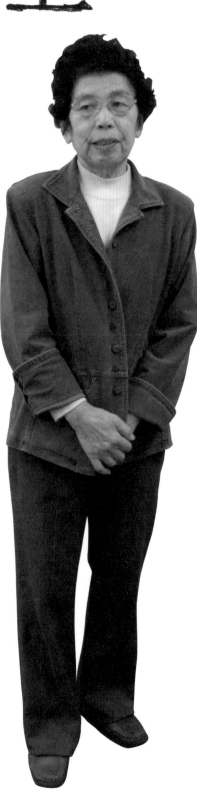

2008

SADAE KASAOKA was a child in Hiroshima in **1945**.

"At the time, I lived with my parents and my ninety-three-year-old grandmother in Eba, 3.8 kilometers from the hypocenter. I was thirteen, in my first year at a girls' school. Every day we had to perform labor service. Until the day before the A-bombing, I had been working outside, demolishing buildings to create a fire lane in Otemachi, near the hypocenter. On August sixth, I stayed home. It was a fine day. My parents had gone out early. As I heard the air-raid "all-clear" siren, I felt relieved, thinking that we would not have to worry about any more enemy planes coming. I cleared the breakfast table and washed the dishes, then finished airing the laundry in the garden and went into the house. I was moving into the room, which had large glass windows facing east. Suddenly, all the windows in front of me became red. It was a beautiful color, like the sunrise mingled with orange. I heard a thundering boom, the glass broke, and the shattered pieces whizzed at me. The blast knocked me down and I lost consciousness. When I came to, I put my hand on my head. It was slimy. I thought, *I have to escape*, and I ran to the neighborhood air-raid shelter with my grandmother. Some neighbors were already there, but nobody knew anything. After a while, I left the shelter. Fallen roof tiles and plaster of houses were scattered everywhere. About 9 A.M., a man in the neighborhood, who had been downtown, returned. He was so badly burned, his skin peeled so that his face and arms looked pink. He shouted, 'With a flash everything was destroyed.' That night, we heard that Father had taken shelter in a relative's house in Oko-cho. My brother went there and came back with him in a two-wheeled cart. My father, lying on a door board, looked dead. His face was swollen and his clothes were burned off, leaving him naked. I could identify him just by his voice. We had no medicine, so we grated cucumbers and potatoes to make a dressing. His body was burned not only on the surface but also inside. He asked for my mother: 'I tried to escape with Kichi but I lost her.' He wanted water desperately. At that time we were told that burned people would die if they drank water, so I lied to him and said that the water supply was cut off. My father loved beer. He pleaded, 'If there is no water, I want beer instead.' But I didn't give him anything to drink, which is still one of my greatest regrets. All I could do was fan him, because it was hot and flies could infest his wounds. The wounds festered and were crawling with maggots inside and out. I hurried to the field for something juicy to give him instead of water. I found tomatoes there, and wrenched them off into a basket. Then I looked up and saw a strange scene. People, whose whole bodies looked whitish, had their hands up in front of their chests with something tattered hanging from them. They were staggering in procession toward the military hospital, covered in ash. That tattered thing was their peeling skin.'"

SADAE KASAOKA MADE THESE PAPER CUT-OUTS TO ILLUSTRATE HER FATHER'S INJURIES

"When I touched him, his black skin peeled and showed the muscle underneath."

In June **1905**, the Curies finally traveled to Sweden to collect their Nobel Prize. Pierre was taken with the landscape an

the lakes, the houses built of redwood. In a letter home he marveled, "At the moment of our voyage, there was no night."

HALF-LIFE

"Radium compounds appear to change with
lapse of time, doubtless under the action
of their own radiation."

—Marie Curie

At the dawn of the twentieth century, radium had mesmerized the public with its sublime glow. However, a fuller picture was beginning to come into focus. The most famous case of illness and death linked to radium took place in West Orange, New Jersey. In the early 1920s, U.S. Radium Corporation employed some eight hundred women, mostly in their late teens and early twenties, to coat watch-dial numerals with a film of Undark paint using tiny brushes of just three or four horsehairs. To maintain a brush point fine enough for the precise calligraphy, the girls would twirl the bristles between their lips. As they completed their quota of 250 dials a day, they swallowed small amounts of the odorless, mild-tasting radioactive paint.

Radium is a "bone-seeker." Introduced into the body, it replaces the calcium in bones, causing them to deteriorate. Before long a series of crippling symptoms — decomposing jaws, bleeding gums, severe anemia, immobilizing weakness — overwhelmed worker upon worker. One girl fainted at the sight of her own reflection: her body glowed as if lit from within. With the help of the National Consumers League and journalist Walter Lippmann, editor of the *New York World* (and the man who would later popularize the term "cold war"), five of the women sued U.S. Radium. Their eventual legal victory in 1928 was a landmark for workers' rights. It was too late, however, to lift any names from the secret list in a "Doom Book" that one local doctor compiled to track fatalities.

Polonium's infamy came later. In London sometime between October 16 and November 1, 2006, the radioactive isotope polonium 210 acted as poison in the death of exiled former KGB officer Alexander Litvinenko. According to his father, Litvinenko was "killed by a little, tiny nuclear bomb." Before his death, Litvinenko accused Russia's then-president, Vladimir Putin, of orchestrating the poisoning. Putin denied the charge. American journalist Edward Epstein began an investigation shortly after Litvinenko's death.

EDWARD EPSTEIN: "Let's say for example that you find a suitcase nuclear bomb and someone had been hit over the head with it. And he is dead, or dying, lying there. You say, well, somehow, this bomb collided with the guy's head. But you wouldn't conclude that someone had brought the suitcase nuclear bomb there to hit a guy over the head. Same thing with the polonium.

"Polonium is an ineffective poison. It has to get into the bloodstream. If you eat it with food, it might not get in through the intestinal wall. It won't go through the skin unless you have an open cut, unless it is injected, or unless you breathe a large amount in — like you are inhaling a cigarette. And once it gets into the bloodstream, it doesn't kill you right away. It takes about three to four weeks. There are a thousand other poisons they could have used. They could have smuggled in, for example, Ricin — made of castor beans — a deadly poison, undetectable and without an antidote. Or cyanide. Or various kinds of mushrooms, like the destroyer angel.

"Once we get the idea that this was not a poison — even if it was used as a poison once they had it there — what other purpose could it have? There are two purposes I can think of. It could be used by an intelligence service in a very sophisticated way to trace the path of some documents. The second possibility is nuclear smuggling. Had it been found in Iran, or in Syria, we would have said, 'You are building a nuclear weapon.'"

In April **1906** the Curies and their daughters, Irène and
Eve, took an April holiday in the meadows of St. Remy-les-Chevreuse,
southwest of Paris. Pierre was not well. In a shifting half-letter,
half-diary entry, Marie recorded those "two sweet days under a mild sun."
"We collected flowering chestnut branches and gathered a huge
bouquet of large water buttercups that you loved so....
We slept nuzzled against each other, as always....
The next day you were weary, the weather was divine....
Irène chased butterflies with a mean little net and you thought she
wouldn't catch any. Yet she did seize one to your great indigestion....
I took off her jumper in the middle of the prairie, and she ran in her
little blue knit trousers, arms and neck naked, to the house to find
her cloth jacket.... I sat down against you and lay
across your body.... I had a little clenching
in my heart holding you there, but
I felt happy....

...I had the feeling that I had frequently
felt during this recent time, that nothing troubled us."

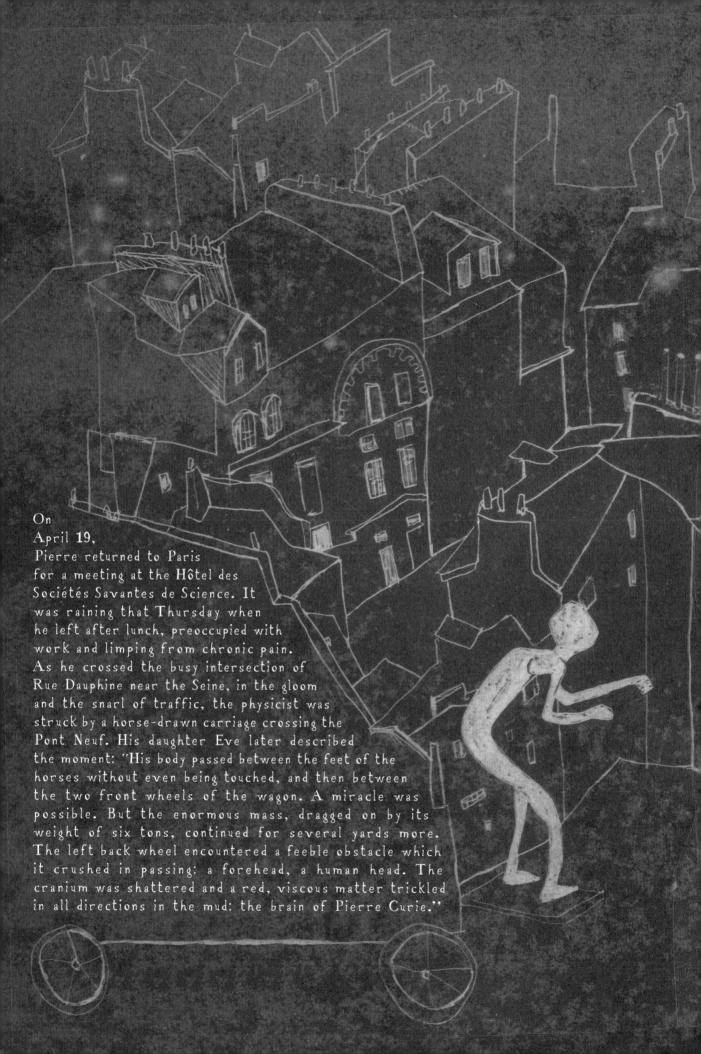

On
April 19,
Pierre returned to Paris
for a meeting at the Hôtel des
Sociétés Savantes de Science. It
was raining that Thursday when
he left after lunch, preoccupied with
work and limping from chronic pain.
As he crossed the busy intersection of
Rue Dauphine near the Seine, in the gloom
and the snarl of traffic, the physicist was
struck by a horse-drawn carriage crossing the
Pont Neuf. His daughter Eve later described
the moment: "His body passed between the feet of the
horses without even being touched, and then between
the two front wheels of the wagon. A miracle was
possible. But the enormous mass, dragged on by its
weight of six tons, continued for several yards more.
The left back wheel encountered a feeble obstacle which
it crushed in passing: a forehead, a human head. The
cranium was shattered and a red, viscous matter trickled
in all directions in the mud: the brain of Pierre Curie."

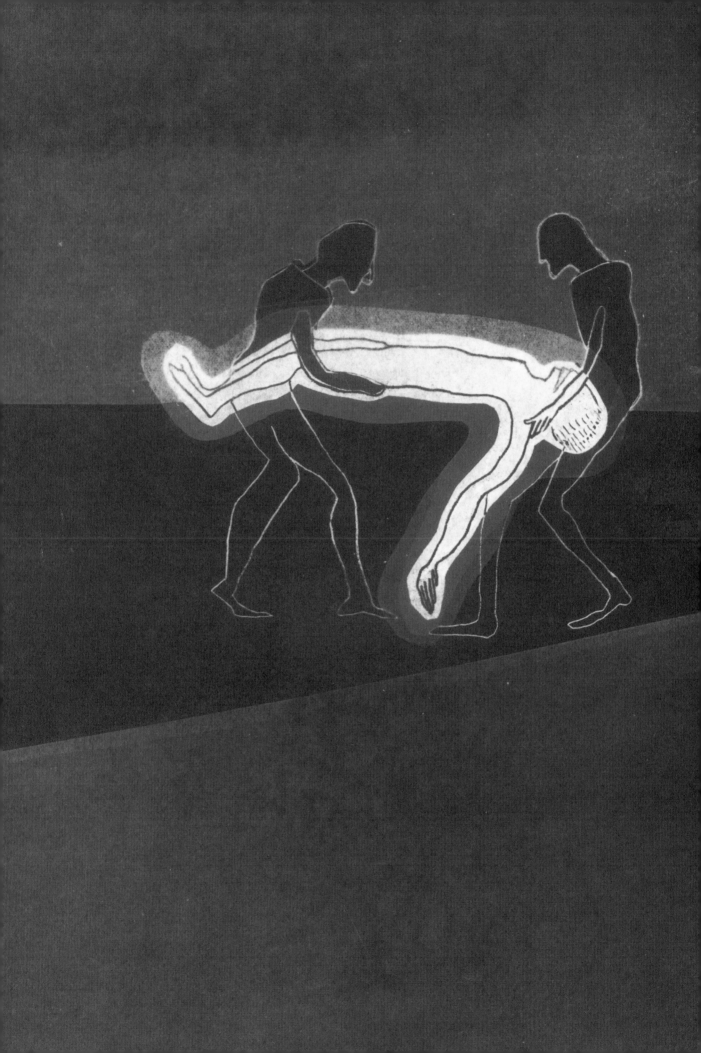

Pierre's original schedule would have kept him at a second meeting just two streets away. However, an ongoing strike had temporarily shuttered that building and diverted his route. The rain made for poor visibility and slippery roads. The carriage was carrying some **13,000** pounds of military gear, making it difficult to stop suddenly or reverse course.

For a disaster created by multiple, unanticipated failures in a system — a collection of small, simultaneous mishaps that lead to one massive catastrophe — sociologist Charles Perrow coined the phrase "normal accident." "We start with a plant, airplane, ship, biology laboratory, or other setting with a lot of components…. Then we need two or more failures among components that interact in some unexpected way…. Each of the failures — design, equipment, operators, procedures, or environment — [is] trivial by itself…. The failures [become] serious when they interact."

Such, Perrow contends, was the case on March **28, 1979,** when one of the two reactors at the Three Mile Island nuclear power plant near Harrisburg, Pennsylvania, descended into partial meltdown. An orchestra of leaky valves, inadvertently concealed indicators, overflowing water tanks, contradictory emergency signals, and operator confusion created a disaster that began and was compounded in a matter of seconds, yet took days to unfold, understand, and stop. Mary Osborn can see the Three Mile Island plant from her bedroom window. Some days she can smell chocolate from the Hershey plant fourteen miles away; some days the aroma of yeasty bread from nearby Capital Bakers floats her way. On that Wednesday morning in **1979,** she remembers, the air filled instead with a sharp, metallic taste. Since the accident, Mary Osborn has collected mutant plant specimens from the area, which she photographs, dries, and preserves. Her collection includes this pink rose. It has two complete sets of leaves and petals but no reproductive parts. It is sterile.

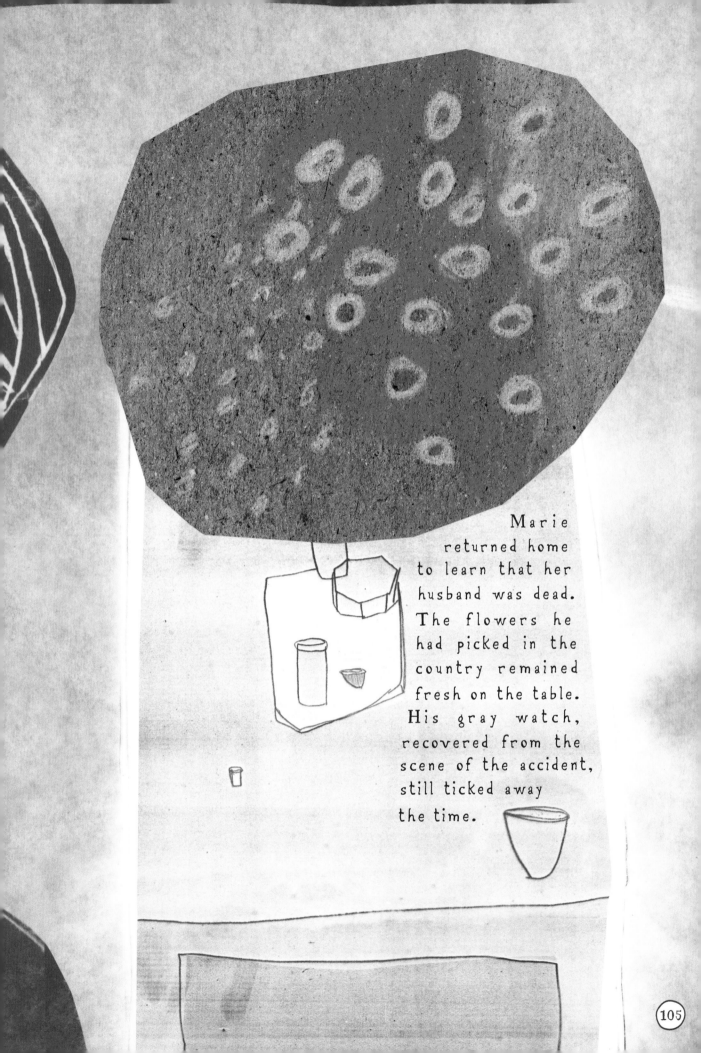

Marie returned home to learn that her husband was dead. The flowers he had picked in the country remained fresh on the table. His gray watch, recovered from the scene of the accident, still ticked away the time.

MARIE: "They brought you in and placed you on the bed.... I kissed you and you were still supple and almost warm.... Pierre, my Pierre, you are there, calm as a poor wounded man resting in his sleep, his head bandaged. Your face is sweet, as if you dream. Your lips, which I used to call hungry, are livid and colorless.... I kissed your eyelids.... We put you in the coffin Saturday morning, I held your head.... Your coffin was closed and I could see you no more.... We saw you go down into that big deep hole.

"I was alone with the coffin and I put my head against it.... I spoke to you. I told you that I loved you and that I had always loved you with all my heart.... It seemed to me that from this cold contact of my forehead with the casket something like a calm or an intuition came to me from which I would yet find the courage to live. Was this an illusion or was it an accumulation of energy coming from you and condensing in the closed casket which thus came to me as an act of charity on your part?

"My Pierre, I got up after having slept rather well, relatively calm. That was barely a quarter of an hour ago, and now I want to howl again — like a savage beast."

CHAPTER 7

ISOLATION

"A glass vessel containing radium
spontaneously charges itself with
electricity. If the glass has a weak
spot, for example, if it is scratched by
a file, an electric spark is produced at
that point, the vessel crumbles like a
Leiden jar when overcharged, and the
electric shock of the rupture is felt by
the fingers holding the glass."

—Marie Curie

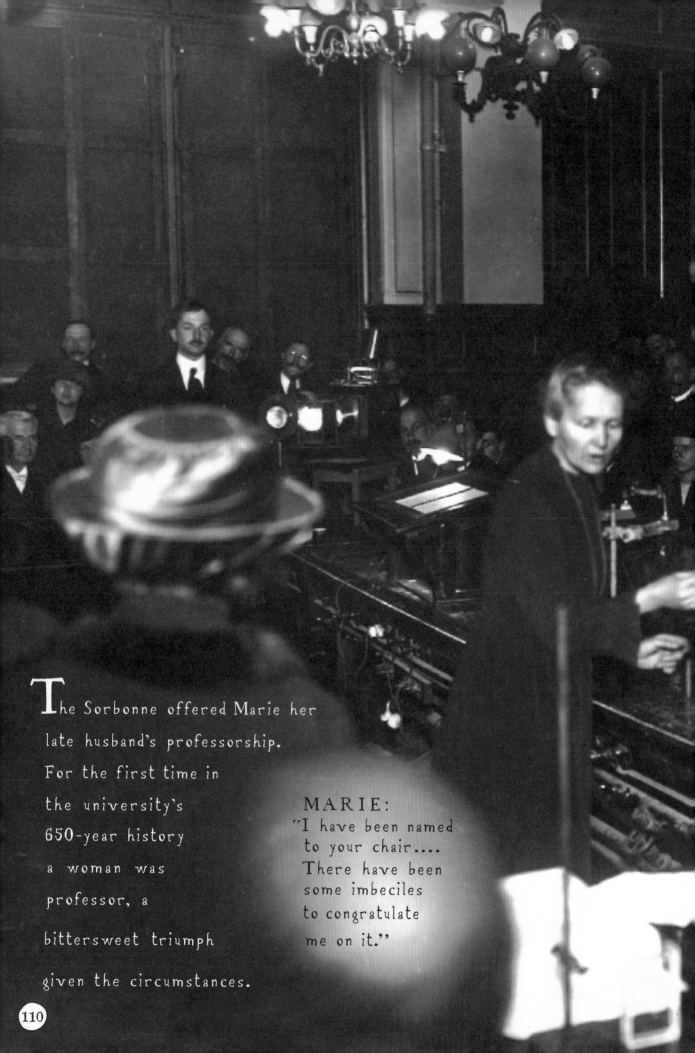

The Sorbonne offered Marie her
late husband's professorship.
For the first time in
the university's
650-year history
a woman was
professor, a
bittersweet triumph
given the circumstances.

MARIE:
"I have been named
to your chair....
There have been
some imbeciles
to congratulate
me on it."

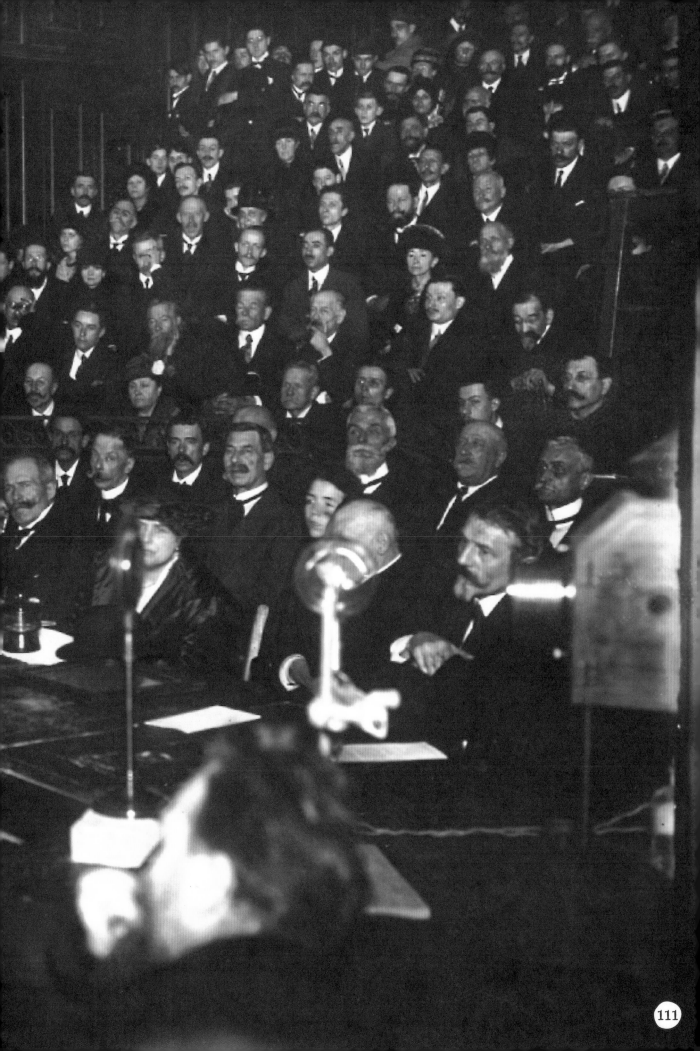

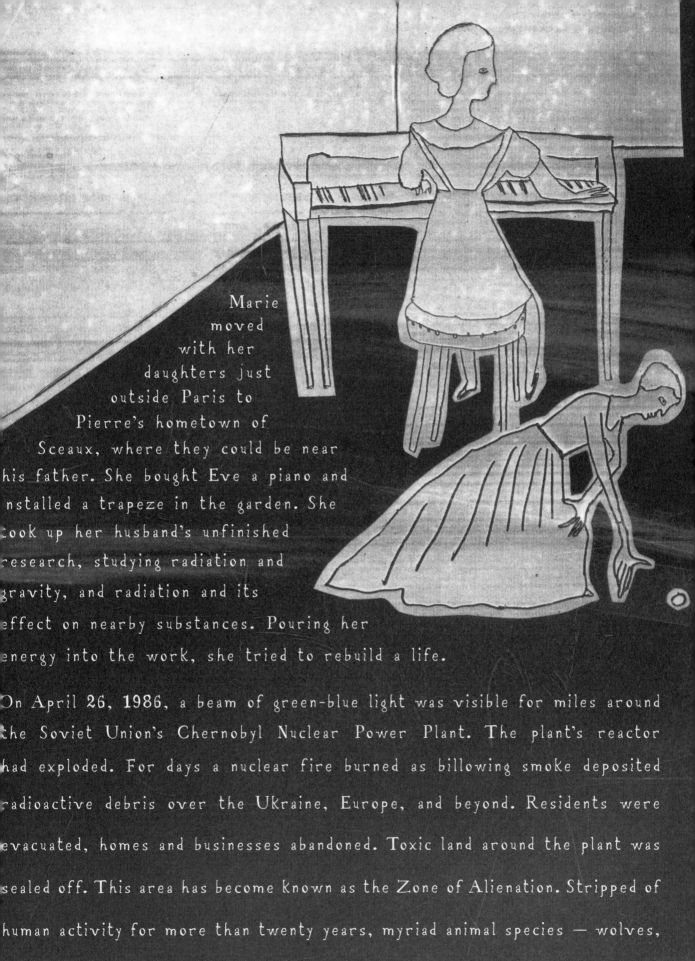

Marie moved with her daughters just outside Paris to Pierre's hometown of Sceaux, where they could be near his father. She bought Eve a piano and installed a trapeze in the garden. She took up her husband's unfinished research, studying radiation and gravity, and radiation and its effect on nearby substances. Pouring her energy into the work, she tried to rebuild a life.

On April 26, 1986, a beam of green-blue light was visible for miles around the Soviet Union's Chernobyl Nuclear Power Plant. The plant's reactor had exploded. For days a nuclear fire burned as billowing smoke deposited radioactive debris over the Ukraine, Europe, and beyond. Residents were evacuated, homes and businesses abandoned. Toxic land around the plant was sealed off. This area has become known as the Zone of Alienation. Stripped of human activity for more than twenty years, myriad animal species — wolves, wild boar, raptors, bears, lynx — have migrated to the area, causing some to announce the creation of an inadvertent wildlife refuge: an accidental Eden. 113

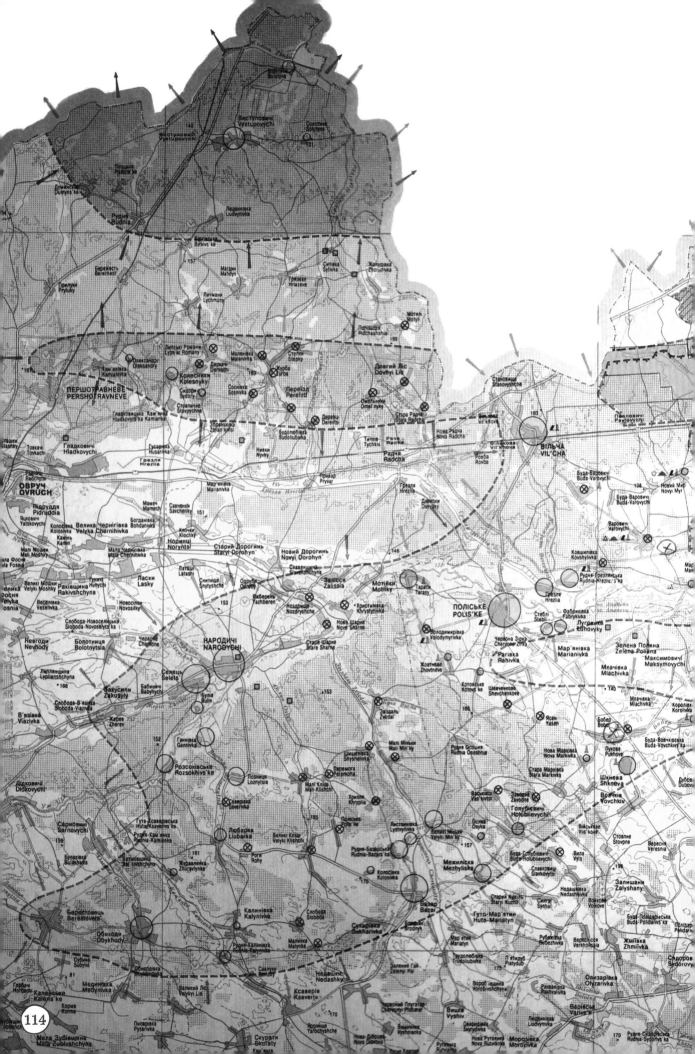

CHERNOBYL AREA SITUATIONAL MAP

СИТУАЦІЙНА КАРТА
СИТУАЦИОННАЯ КАРТА

(Complete key on Page 196)

Chernobyl Nuclear Power Plant Sarcophogus

Approximate Border of Compulsory Evacuation Zone

Hand-drawn X's indicate Tim Mousseau's field sites

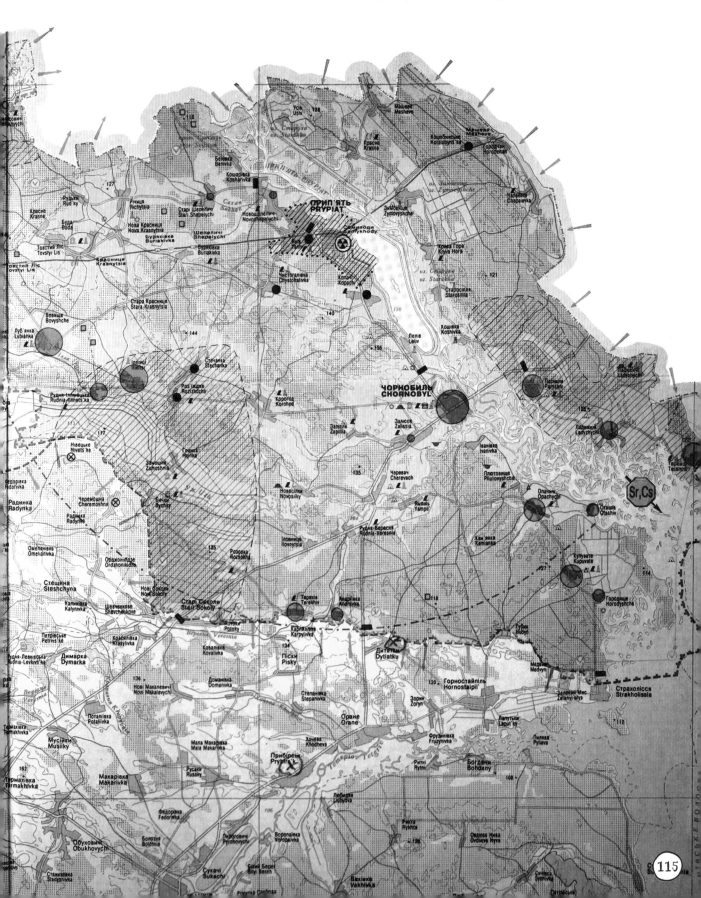

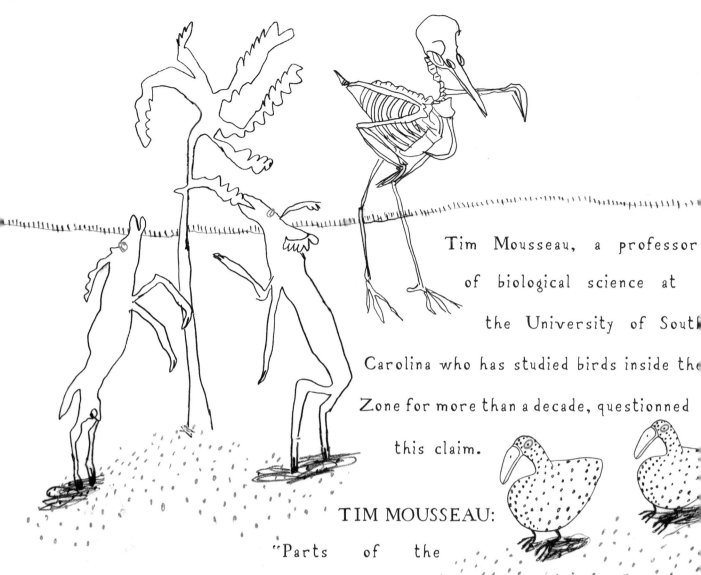

Tim Mousseau, a professor of biological science at the University of South Carolina who has studied birds inside the Zone for more than a decade, questionned this claim.

TIM MOUSSEAU:

"Parts of the site are up to **10,000** times more radioactive than a normal environment. For the first few years, it was very, very contaminated. There was a lot of iodine **131**, cesium **137**, and strontium **90**. Plutonium **239** was also was released in fairly considerable quantities. There is still a ton of it around and it is biologically extremely active. It has a half-life of twenty-five thousand years. So it will be there forever, effectively. The question is: How does this impact the overall functioning of the ecosystem? For the last nine or ten years we've been working with the bird population, primarily barn swallows, tracking their survival. These birds are quite warm-blooded. Very cuddly, very charismatic organisms. They employ an array of strategies for expressing color. The most common mode for expressing bright reds and yellows is caratinoids. They make use of the melanin that we use in our skin for the red on their throat. The iridescent greens and blues are due to the physical structure and how it refracts the light — a little prism in the feathers.

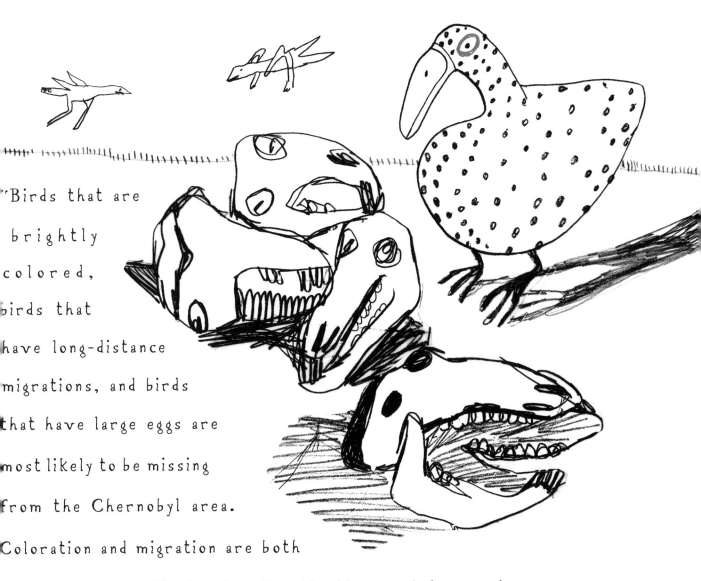

"Birds that are brightly colored, birds that have long-distance migrations, and birds that have large eggs are most likely to be missing from the Chernobyl area. Coloration and migration are both

consumers of antioxidants. Caratinoids are taken up in the diet and used to produce bright reds and yellows. When they use these caratinoids for coloring, they don't have them available for fighting contaminants. We find in the most contaminated areas fifteen to twenty percent of the birds have partial albinism — patches of white feathers. Coloring is a key component of sexual selection. The birds that can make use of these antioxidants for coloration are often the ones most successful in attracting mates. [The] evolutionary fitness of an individual is the product of survival and reproductive ability. Individuals have to trade off the allocation of these limited resources. Of course, you can't reproduce if you don't survive. But then, if you reach reproductive age and you are not attractive to the other sex, your fitness is also zero."

CHAPTER 8
EXPOSURE

"Certain bodies...become luminous
when heated. Their luminosity disappears
after some time, but the capacity of
becoming luminous afresh through heat
is restored to them by the action of a spark,
and also by the action of radium."

—Marie Curie

In the spring of 1910 a flush appeared over Marie's cheeks.

She pinned a flower to her dress.

120

Marie had taken a lover.

Four years after the death of her husband, Marie had fallen for Pierre's former student, physicist Paul Langevin. Mere hours of separation prompted the exchange of impassioned letters.

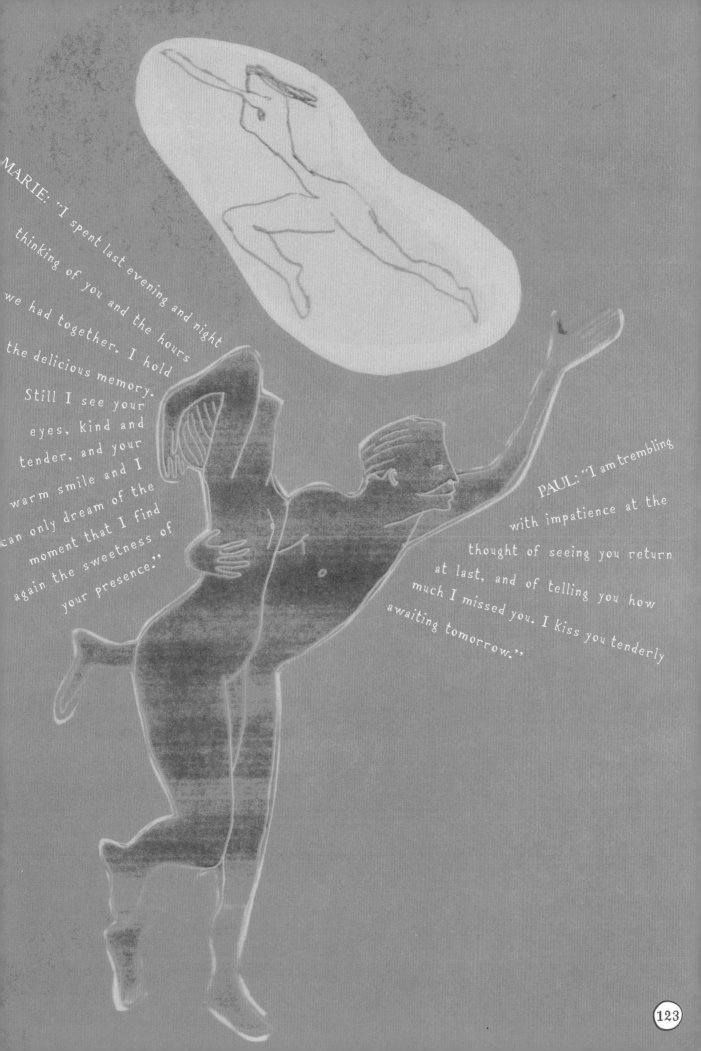

MARIE: "I spent last evening and night thinking of you and the hours we had together. I hold the delicious memory. Still I see your eyes, kind and tender, and your warm smile and I can only dream of the moment that I find again the sweetness of your presence."

PAUL: "I am trembling with impatience at the thought of seeing you return at last, and of telling you how much I missed you. I kiss you tenderly awaiting tomorrow."

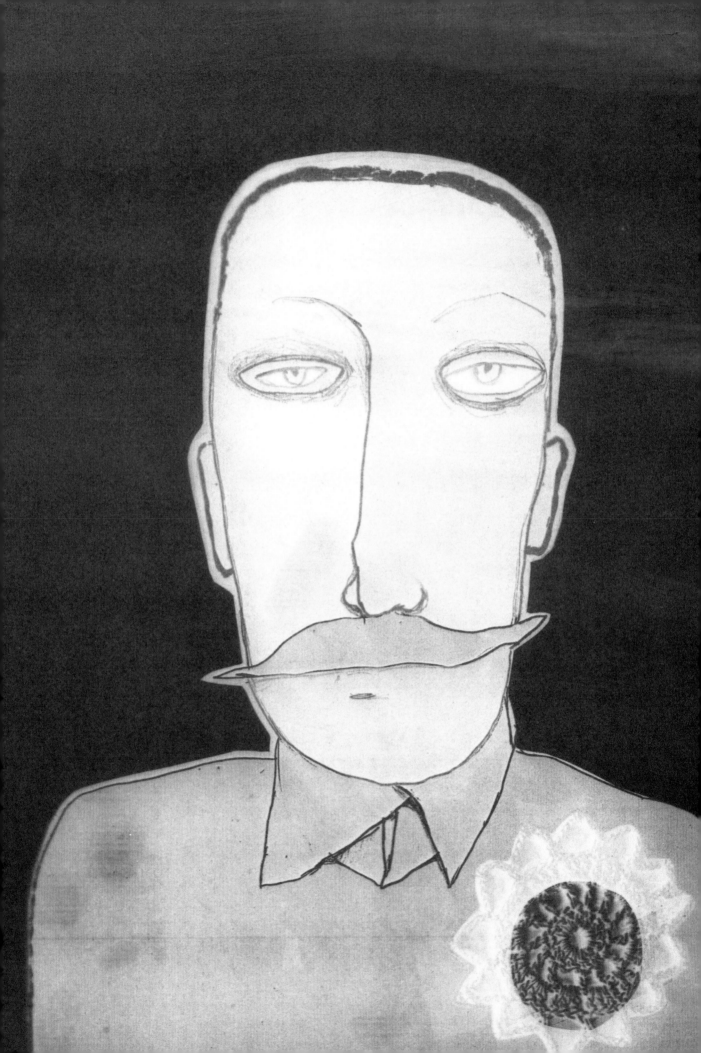

Paul Langevin was tall
with a thriving mustache. He was
born on Paris's Montmartre hillside in
1872, next to a crumbling piano factory-
turned-tenement, the building where
Pablo Picasso would later paint *Les
Demoiselles d'Avignon*. The Sacré Coeur
basilica was just being erected;
neighborhood children climbed on its
skeleton frame as if it were a jungle
gym. Langevin's rise in the scientific
community was swift, his accomplishments
many. He was brilliant: acclaimed for an
ingenious thesis on ionized gases. He was
daring: he scaled the Eiffel Tower to
find the purest possible air for a
study of electric currents in the
atmosphere. He was celebrated:
elected to the Collège de France
and the Academie des Sciences,
awarded the Hughes Medal
and the Copley Medal. And
he was heroic: active
in the French Resistance during World War
II, arrested by the Nazis, president of the League of the
Rights of Man. "It seems to me certain," Albert Einstein wrote after
Langevin's death, "that he would have developed the special theory of
relativity if it had not been done elsewhere." Who wouldn't
rejoice in the union of Paul and Marie — a coupling of giants?

His wife.

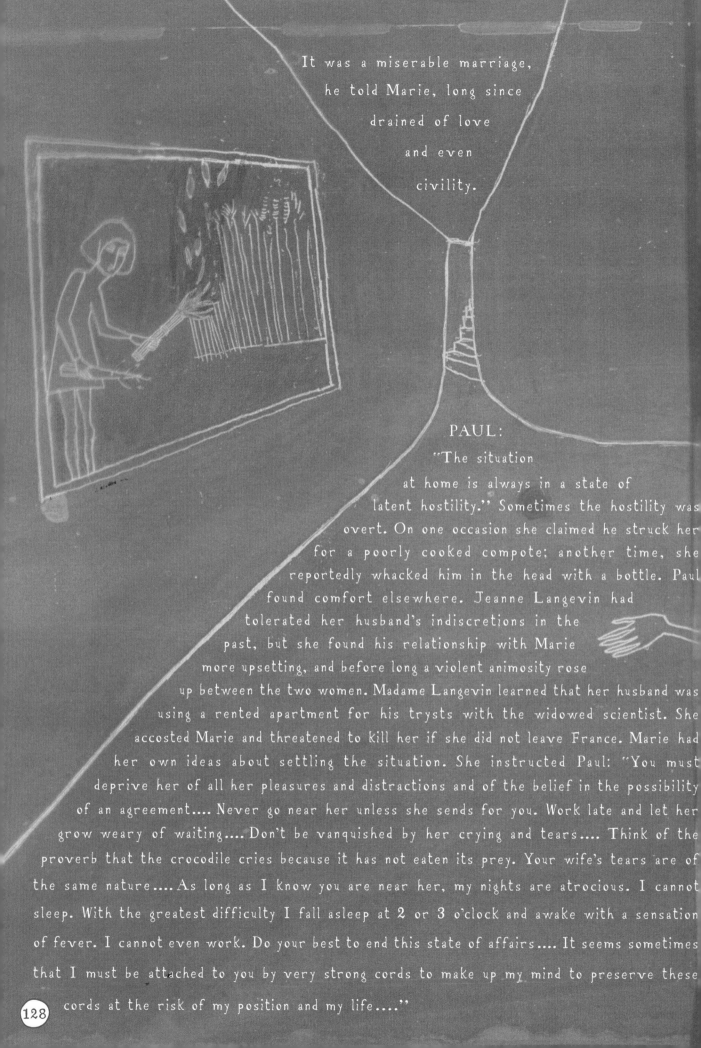

It was a miserable marriage,
he told Marie, long since
drained of love
and even
civility.

PAUL:
"The situation
at home is always in a state of
latent hostility." Sometimes the hostility was
overt. On one occasion she claimed he struck her
for a poorly cooked compote; another time, she
reportedly whacked him in the head with a bottle. Paul
found comfort elsewhere. Jeanne Langevin had
tolerated her husband's indiscretions in the
past, but she found his relationship with Marie
more upsetting, and before long a violent animosity rose
up between the two women. Madame Langevin learned that her husband was
using a rented apartment for his trysts with the widowed scientist. She
accosted Marie and threatened to kill her if she did not leave France. Marie had
her own ideas about settling the situation. She instructed Paul: "You must
deprive her of all her pleasures and distractions and of the belief in the possibility
of an agreement.... Never go near her unless she sends for you. Work late and let her
grow weary of waiting.... Don't be vanquished by her crying and tears.... Think of the
proverb that the crocodile cries because it has not eaten its prey. Your wife's tears are of
the same nature.... As long as I know you are near her, my nights are atrocious. I cannot
sleep. With the greatest difficulty I fall asleep at 2 or 3 o'clock and awake with a sensation
of fever. I cannot even work. Do your best to end this state of affairs.... It seems sometimes
that I must be attached to you by very strong cords to make up my mind to preserve these
cords at the risk of my position and my life...."

Marie had experienced heartbreak and saw Paul's troubles as evidence that he, too, understood disappointment. It made them all the more compatible, she thought. Langevin, though, hesitated. He continued seeing Marie, but he also continued being married.

The ongoing deception taxed their happiness. They had to conspire to arrange every encounter. MARIE: "Be sure you are not followed by anyone when you come to me.... The concièrge knows my name and my occupation: tell him I give you lessons if you like."

In the spring of 1911, Madame Langevin had the lovers' letters stolen from the hideaway apartment. For eight months she taunted Paul and Marie with the threat of making them public. The consequences of such a disclosure were plain: without evidence, the affair was merely a theory, invisible and unproven.

Professor Mongi Abidi, director of the Imaging, Robotics, and Intelligence Systems Laboratory at the University of Tennessee, helps the United States protect its nuclear secrets.

DR. MONGI ABIDI: "What we are developing is a video-based surveillance system, primarily to protect the nuclear weapons complex. It's to ensure custody and to make sure there is no foul play. 'High-value assets' in general refers to bomb material. Say a warhead is being moved from point A to point B, the protocol requires the involvement of several people. All authorized personnel and procedures are electronically logged. We look at the ID-type features — the face, the iris — accurate facial features that can be matched against a database of all authorized personnel. Everybody in the facility is tagged.

"This is a multicamera system — a Pan-Tilt-Zoom system. The cameras communicate through several computers. If it's a transportation event, there is one camera that would follow the object, and another that would follow the person. You take a picture of the entire face. You remove the hair. You look at the eyes, the location of the eyes, the space in between the eyes, the color. There is a very quick match based on the color of the eyes. The algorithms use from nineteen to sixty features in the face. If there is an abnormality, there's a protocol for intervention. You seal the area. A line of management is brought in. Doors close. Some devices are smart enough to self-destruct.

"The idea is to make automated surveillance systems that cut down on the number of hot bodies that you have to have, which is very, very costly. People doze off, get bored, get distracted. A camera can work twenty-four hours a day. It can read your ID from one hundred meters. We have a little pancake robot that gets under the vehicle and checks if your vehicle has any irregularities or any weapons before you get into the complex. We're working to have similar things for other assets. I don't think I'm at liberty to say what those other assets are.

"There are three major laboratories and three manufacturing plants in the U.S. that handle all the nuclear material and warheads. There are basically two activities: one, nuclear waste and the other, nuclear weapons, which don't become really harmful until they are exploded."

In 1956 Los Alamos scientist Roger Ray made this pinhole camera out of a Dixie cup and black masking tape in order to secretly photograph the United States' thermonuclear bomb tests in the Pacific Ocean. The tests, code-named "Operation Redwing," were conducted at the Bikini and Eniwetok atolls to study corneal-retinal burns caused by nuclear blasts. Rabbits and monkeys were used as guinea pigs. Ray later became a vocal advocate on behalf of Bikini islanders displaced by the U.S. testing program.

RADIOACTIVE DECAY

Radioactive elements are unstable. They undergo spontaneous decay. That is, the unstable nucleus emits energetic particles and radiation, thus transforming into an isotope of a different element. This process continues until a stable form is reached. "Half-life" is the amount of time it takes for half of the nuclei of a given sample to undergo radioactive decay. The primary element is called the "parent"; the product is referred to as the "daughter" element.

ISOTOPE	HALF-LIFE
URANIUM-238	4½ BILLION YEARS
THORIUM-234	24 DAYS
PROTACTINIUM-234	1.16 MINUTES
URANIUM-234	245,500 YEARS
THORIUM-230	75,380 YEARS
RADIUM-226	1,620 YEARS
RADON-222	3.8 DAYS
POLONIUM-218	3 MINUTES
LEAD-214	26.8 MINUTES
BISMUTH-214	20 MINUTES
POLONIUM-214	0.164 MICROSECONDS
LEAD-210	22.3 YEARS
BISMUTH-210	5 DAYS
POLONIUM-210	138 DAYS
LEAD-206	STABLE

Marie struggled to continue working.

She was in the midst of determining a decay series — the step-by-step breakdown of radioactive element — for polonium.

From seven tons of raw pitchblende, in four years the Curies had distilled just one tenth of a gram of radium — a mere pinprick! The proportion of polonium present in the material was even smaller, indeed, five thousand times smaller. Polonium was revealing itself to be extremely radioactive and, with a half-life of only 138 days compared to radium's 1602 years, highly ephemeral.

In the autumn of 1911 both she and Paul Langevin traveled to Brussels for the first International Solvay Conference. Nearly two dozen of the world's eminent scientists gathered in Belgium to discuss "Radiation and the Quanta." Marie was the only woman present. Albert Einstein, thirty-two, was the youngest attendee.

On November 4, one day after the conference ended, Marie received a telegram stating that Mme. Langevin had publicly accused her and Paul of having a love affair and running away together — though for the time being she had withheld the stolen letters. Three days later the papers announced that Marie Curie had won another Nobel Prize, this time in chemistry. Not only was she already the first woman to receive the prize, but now she was poised to become the first person, man or woman, to win it twice.

There was no time to celebrate. Despite denials from both Marie and Paul, the scandal was intensifying. Mme. Langevin charged her husband with enjoying "adulterous relations with a concubine in the conjugal dwelling." She demanded money and custody of the children. He refused. She released the letters. Newspapers around the world reported on "the greatest sensation in Paris since the theft of the Mona Lisa."

French papers largely sympathized with Jeanne Langevin, churning out maudlin articles about selfless devotion to family and long-silent suffering. Marie was cast as the conniving tramp who had ensorcelled a married man. Worse, she was a dangerous foreigner—a Jew! they shouted, inaccurately. The story was proof, journalist Gustave Téry wrote, that France was "in the grip of the bunch of dirty foreigners, who plunder it, soil it, dishonor it." He scorned the implication in Marie's letters that she had a "right to happiness" as "naïve and ferocious selfishness" and invoked another drama from France's recent past to disparage Marie and her supporters: "These intellectuals are almost all old acquaintances from the Dreyfus affair...preferring anarchy to order." He mocked her, writing sarcastically, "'I'm a foreigner! I'm an intellectual! I'm a liberated woman!'" In a final swipe, he dismissed her scientific accomplishments: "Her honor has nothing to do with the phenomena of radioactivity, which was sufficiently understood before it was discovered by Pierre Curie." A date was set for the Langevin trial—to begin just as Marie was scheduled to accept her Nobel Prize in Stockholm.

Then the Nobel committee waffled. Biochemist Olof Hammarsten, discoverer of guanylic acid (today a flavor enhancer used along with MSG to amplify the savory taste of a dish) wrote to his colleagues. "We must do everything that we can to avoid a scandal and try, in my opinion, to prevent Madame Curie from coming. If she comes and this matter surfaces, that would create difficulties at the ceremony, in particular at the banquet. It would be quite disagreeable and difficult for the Princess apparent as well as for other royal figures in attendance and I don't know who could have her at their table." On December 1, Svante Arrhenius — a Nobel recipient whose theory of atomospheric warming would become known as the "greenhouse effect" and who postulated that spores spread life from planet to planet throughout the universe — wrote to Marie echoing Hammarsten's concern. "I beg you to stay in France; no one can calculate what might happen here.... I hope therefore you will telegraph...that it is impossible for you to come on the 10th of December next and that you write after this a letter saying that you do not wish to accept the prize before the Langevin trial shows the accusations about you are absolutely without foundation."

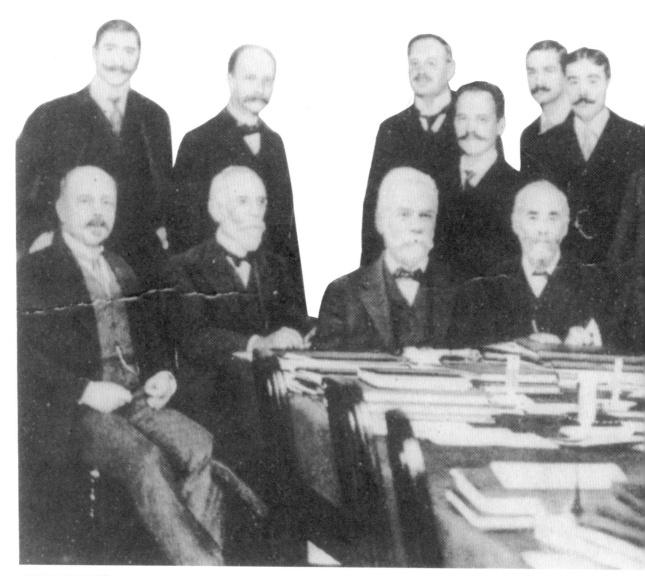

GOLDSCHMIDT PLANCK RUBENS LINDEMANN
NERNST BRILLOUIN SOMMERFELD DE BROG
 SOLVAY

 LORENTZ

Einstein, who nine years earlier had fathered an illegitimate daughter with a former student, and who, though married, would the following year begin an affair with his first cousin, wrote to comfort Marie: "I am convinced... that you [should] continue to hold this riffraff in contempt, whether they feign reverence or seek to satisfy their lust for excitement through you.... I will always be grateful that we have among us people like you and Langevin among us... in whose company one can rejoice. If the rabble continues to be occupied with you, simply stop reading that drivel. Leave it to the vipers it was fabricated for."

Marie responded to the Swedes on December 5: "The steps that you advise seem to me a grave error.... There is no connection between my scientific work and the facts of private life."

HASENOHRL
HOSTELET
KNUDSEN HERZEN JEANS RUTHERFORD LANGEVIN
WARBURG WIEN EINSTEIN
PERRIN MME CURIE POINCARE KAMERLINGH ONNES

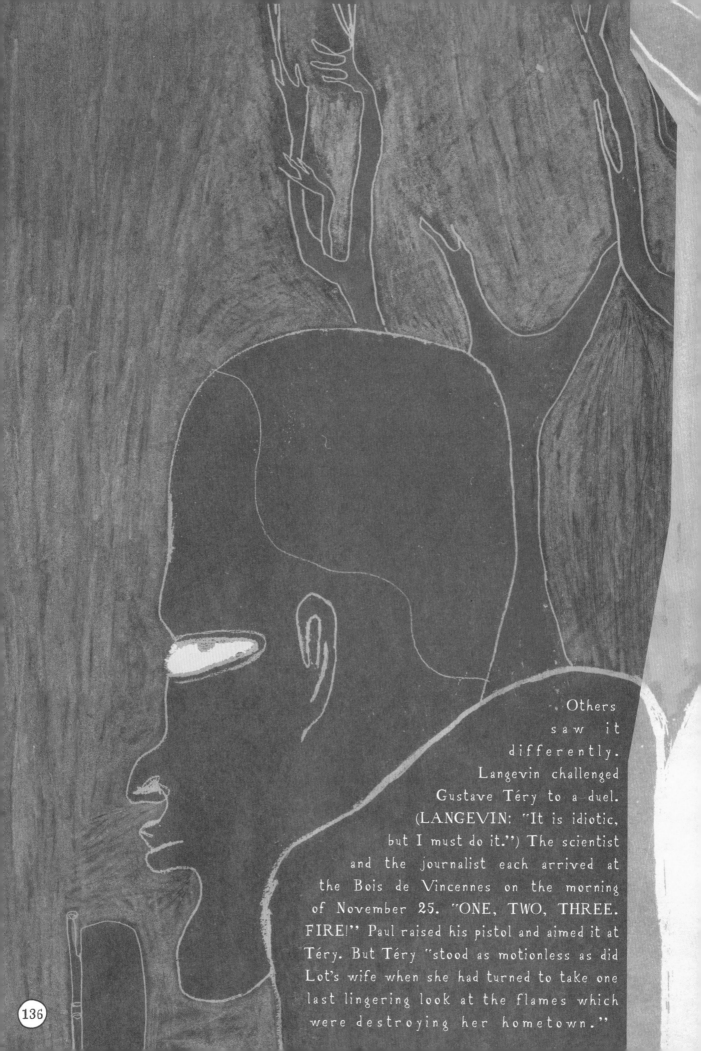

Others
saw it
differently.
Langevin challenged
Gustave Téry to a duel.
(LANGEVIN: "It is idiotic,
but I must do it.") The scientist
and the journalist each arrived at
the Bois de Vincennes on the morning
of November 25. "ONE, TWO, THREE.
FIRE!" Paul raised his pistol and aimed it at
Téry. But Téry "stood as motionless as did
Lot's wife when she had turned to take one
last lingering look at the flames which
were destroying her hometown."

A tense
silence
clutched
the field
of honor.

137

Sixty-five miles northwest of Las Vegas, Nevada, lays a lacerated battlefield 1,375 square miles in size. In the arms race against the Soviets, yoked from direct engagement by the threat of mutually assured destruction, the United States instead attacked a phantom enemy on its own soil. From 1951 to 1992, as part of the country's atomic testing program, nearly one thousand nuclear bombs were detonated in Nevada.

Beginning on September 19, 1957, in anticipation of a ban on the atmospheric tests with their signature mushroom shape and attendant radioactive fallout, the government began detonating bombs underground, anywhere from a few hundred to several thousand feet below the surface. The tests were each given benign-sounding names: Anchovy, Bordeaux, Corduroy, Diamond Dust, Emerson, Feather, Gruyere, and so on. Bill Flangas worked at the Nevada Test Site for forty years.

BILL FLANGAS: "I'm a mining engineer. I see well in the dark. In 1958 I was digging copper in a small town north of here called Ely, Nevada. I got a call. The prime contractor at the test site was trying to put a tunnel together for underground testing. They asked if I was interested and I said no. At that time I had been married for about a year and a half and I had a six-month-old son. I didn't know anything about radiation but I knew enough that I wasn't too eager. But somehow they latched on to me. It was a critical time. The Soviets were threatening and running amok and, you know, the cold war was a real situation. They had nuclear bombs. We had nuclear bombs. There were threats and counterthreats and so on. So I saluted and I obeyed.

"I got caught up in the insanity and what was supposed to be a two- or three-day commitment turned into a forty-year daily situation and another fifteen years after that as a consultant. During my career at the test site, we dug forty-seven miles of tunnel. There were no previous experiences. There was no book of knowledge. 'Rainier' was the first contained, underground nuclear test. That was the fall of 1957. It was the granddaddy of all the subsequent events.

"You had a tunnel. You had a room that was, say, six by six by seven where you put the gadget — you know, the nuclear bomb. When the thing went off, it attained temperatures of a million degrees and it developed pressures of seven million bars. Rainier had a yield of about 1.7 kilotons. In a matter of milliseconds, it vaporized about three feet outside the tunnel walls. It

melted another fifteen feet, and then it expanded into a sphere about one hundred thirty feet in diameter and held that shape for about two minutes. In those two minutes, while you've got this big cavity, the melted stuff is dripping down. It's a glassy material — silica — black and purple and green icicles hanging from the cavity roof and very, very radioactive.

"The ground has layers, some of them harder and some of them softer; the shockwave that comes from this blast hits one, bounces, hits another, bounces back. So you've got some tremendous movement, in all directions — 360 degrees — while the melted material is dripping and collecting into a puddle. After about two minutes the surface can no longer hold, the earth above the ground zero has been pulverized. It collapses and leaves a void. All of it comes crashing down and fills the void with rubble."

Today, craters from these underground tests pock the Nevada Test Site. Other relics are

decomposing "Doom Towns" — make-believe residences, train tracks, motels — that were

built to help study the results of bombing. The houses were filled with appliances and dummy

families. The L.A. Darling Company donated the mannequins and J.C. Penney dressed them

stylishly, in the fashions of the day. Further away, living creatures also absorbed the effects.

Preston Truman grew up in southwest Utah, downwind of the test site.

PRESTON TRUMAN: "The first vivid memory that I have of life is watching an A-bomb

go off. I was sitting on my father's knee. The bomb went off just before dawn. The whole

sky lit up. It gave everything a reddish tint. It was March 1955. They would have A-bomb

parties in Las Vegas. People would set up and stay up drinking and partying all night and get

up and watch the thing go off.

"A boy about my age got sick with leukemia. All of sudden it was, 'He's got it, he's got it, she's got it....' And everyone started to wonder if it was the bomb. All sheep had been wiped out in that area. The doubts grew and the death toll grew and the government said that the reported health problems were Communist propaganda designed to cause problems with our testing program. I remember when one kid my age died of leukemia. I was talking to the woman who was the junior Sunday school superintendent for children under twelve. She was out doing her volunteer duty in the Skywatch station that we had in town — they had people go out and watch for Russian spy planes. They gave them binoculars. She's out doing that and I walked up with a friend and asked her,
"Why did this little boy die?'
'She said, 'Well, it's God's will. There are some spirits that are more precious than others, and God doesn't want to be deprived of them too long. So they come here for just the shortest time.'
'We asked her, 'Could the same thing happen to us?'

"Only if God wants you back.'"

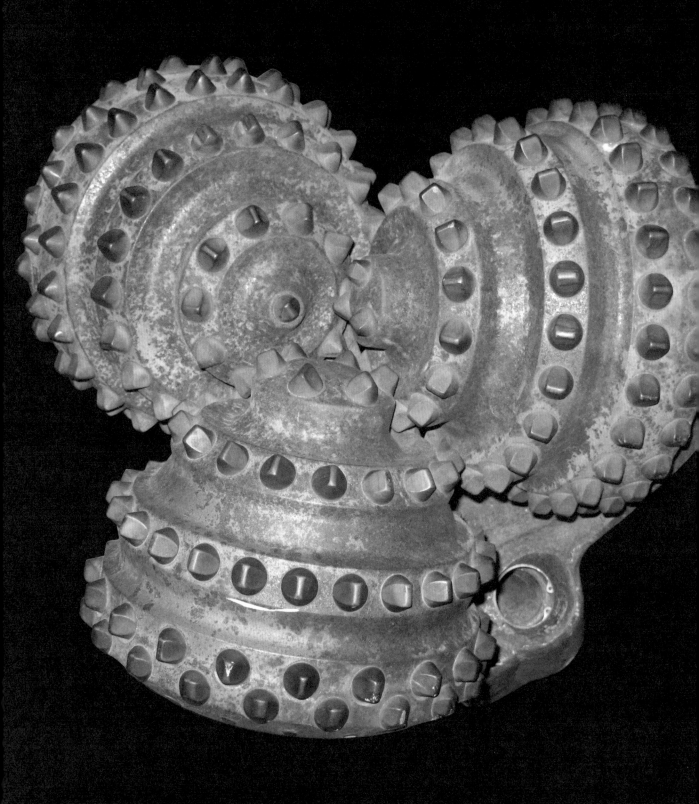

DRILL ASSEMBLIES USED TO EXCAVATE VERTICAL HOLES FOR UNDERGROUND NUCLEAR TESTS

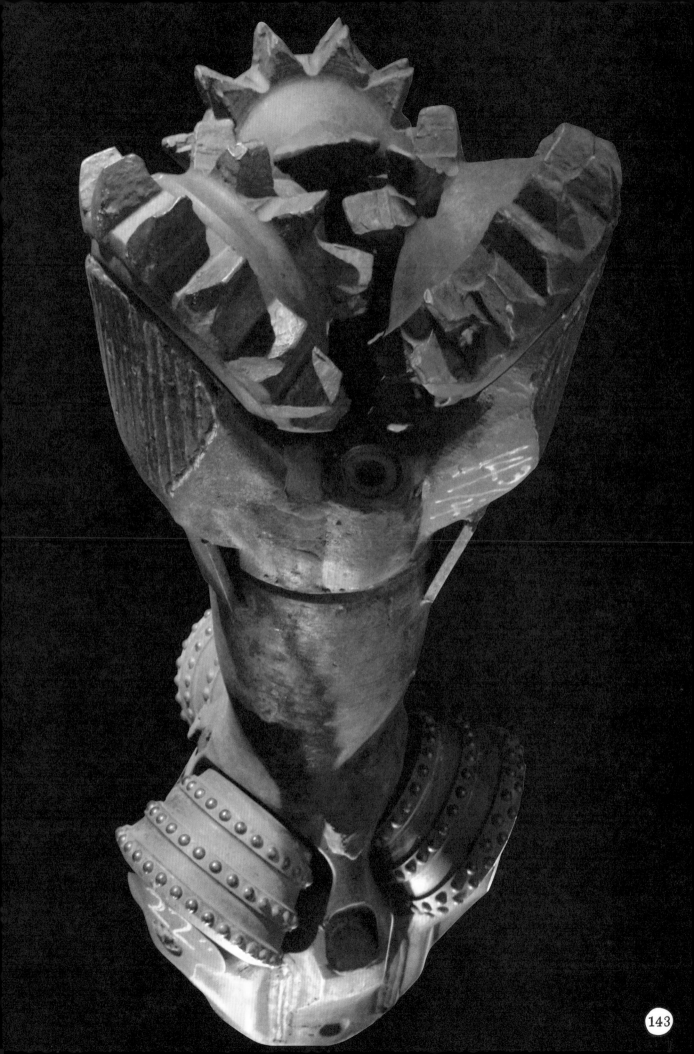

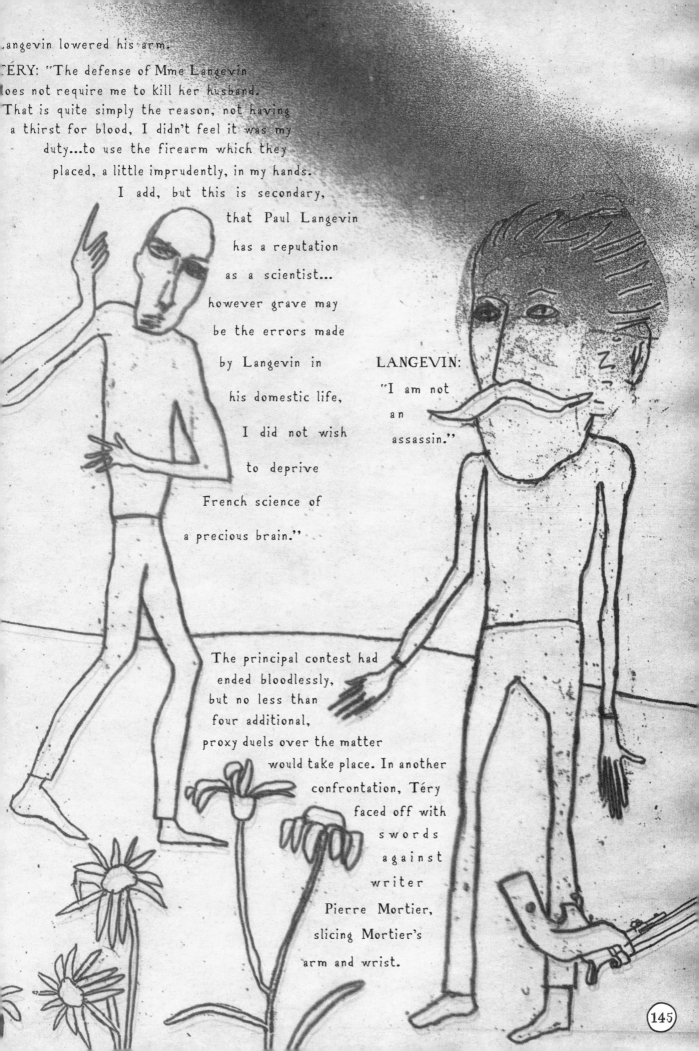

Langevin lowered his arm.

TÉRY: "The defense of Mme Langevin does not require me to kill her husband. That is quite simply the reason, not having a thirst for blood, I didn't feel it was my duty...to use the firearm which they placed, a little imprudently, in my hands. I add, but this is secondary, that Paul Langevin has a reputation as a scientist... however grave may be the errors made by Langevin in his domestic life, I did not wish to deprive French science of a precious brain."

LANGEVIN: "I am not an assassin."

The principal contest had ended bloodlessly, but no less than four additional, proxy duels over the matter would take place. In another confrontation, Téry faced off with swords against writer Pierre Mortier, slicing Mortier's arm and wrist.

145

In mid-December **1911**, bruised but defiant, Marie traveled to Sweden to claim her second Nobel Prize this time in chemistry, for her discoveries of radium and polonium, and for her work advancing the understanding of radium. Following the prize ceremony, there was an eleven-course dinner at the royal palace. Marie sat across from King Gustaf V. The musical entertainment included a piece from Georges Bizet's *Carmen* (in which a temptress inspires duels before being stabbed to death by her spurned lover) and the intermezzo from Moret's *Cleopatra* (a seductress's fate is sealed by a cobra bite). After all the concern about Marie and her stained reputation offending the delicate sensibilities of the royal family,

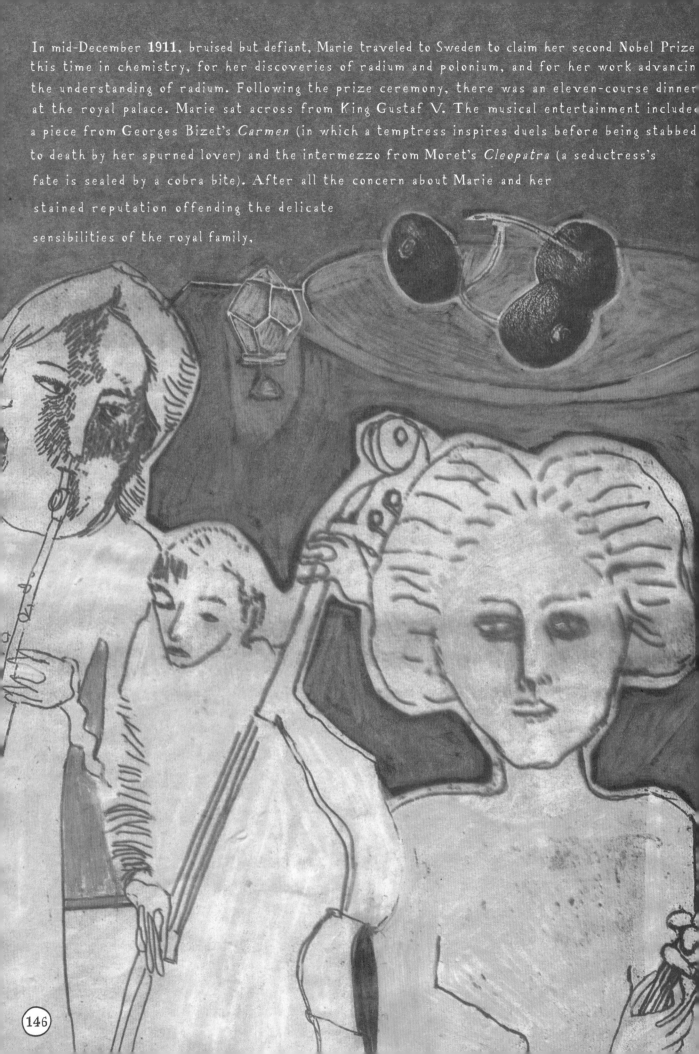

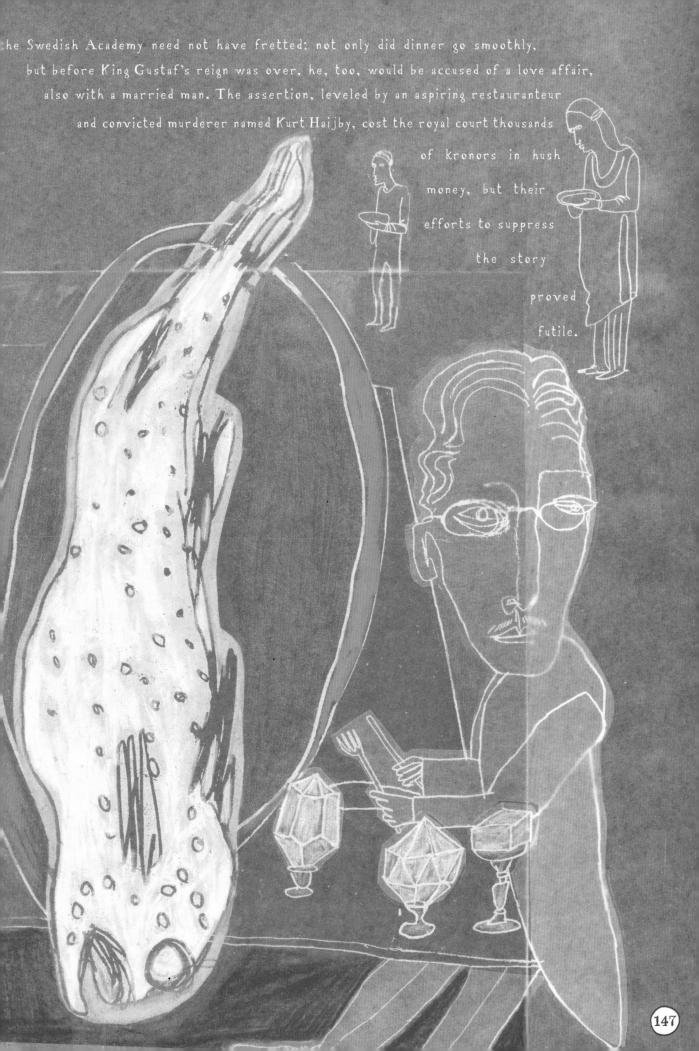

the Swedish Academy need not have fretted; not only did dinner go smoothly, but before King Gustaf's reign was over, he, too, would be accused of a love affair, also with a married man. The assertion, leveled by an aspiring restauranteur and convicted murderer named Kurt Haijby, cost the royal court thousands of kronors in hush money, but their efforts to suppress the story proved futile.

Ten days after the Nobel ceremony, Paul and Jeanne Langevin settled their dispute out of court. Madame Langevin was granted custody of the children with provisions for Paul to visit and guide their education. It was too late, however, to salvage the courtship between Paul and Marie. They would remain in contact and talk regularly about scientific matters, but the romance was over.

Marie returned to Paris and collapsed. Heartbroken, physically and emotionally depleted, she was rushed on a stretcher to the Sisters of the Family of Saint Marie convent. An operation removed lesions on her kidneys. Over the following months she seemed only to deteriorate further. Dwindling to one hundred pounds, she drew up a will. While the Langevin affair no longer made daily headlines, she still faced rumors and leering busybodies. She left Paris for the countryside, traveling under assumed names. She crossed the channel and took refuge with a mathematician friend, Hertha Ayrton, in the south of England. Ayrton studied ripple effects. She had invented a special fan to drive off poisonous gases. She experimented with early electrical light to try and temper its searing heat and insistent hissing. For Marie, she created a secure haven.

Fallout shelters, built to shield occupants from radioactive debris after a nuclear explosion, were commonplace during the cold war. Today, these concrete basement bunkers are viewed mostly as remains of doomsday architecture, but some believe that the need remains. Vic Rantala is president of Safecastle, LLC.

VIC RANTALA: "We provide not only storm and fallout shelters and safe rooms but all kinds of preparedness products. The general market climate out there for this business niche is growing. There was a peak around Y2K. Then there was a little bit of a lull. Then along came 9/11. And after that Hurricane Katrina woke a lot of people up. And then the tsunami on the other side of the world. There is an upward trend in interest.

"I was an analyst for the NSA. I developed a healthy respect for nuclear weapons. It was the mid- to late seventies — the height of the cold war — I was stationed in Frankfurt, Germany. We kept an eye on the Warsaw Pact across the border there in East

Germany and Czechoslovakia. I was nineteen. Our office was called the All-Source Intelligence Center. We monitored signal traffic, radio traffic. We used satellite imagery, human intelligence. Basically we'd be looking to see when and if the Rooskies were coming across the border. I was the designated unit NBC — Nuclear, Biological, Chemical — specialist. I had training digging expedient shelters. If we had to, we could go out and dig a trench.

"I'm back in the same general ballpark here, trying to help people realize, whether it's Russian nuclear weapons or other threats, there are things that we can do to feel better about our world. You don't have to be a wacko. You don't have to be a gun nut. You don't even have to suspect the government of any conspiracies. It's logical to have a plan.

"An average shelter we'd be looking at is about seven feet tall, eight feet wide, and twenty feet long. The base price on a shelter that size is about $23,000. Then there is the cost of installation, which is about three thousand dollars. Then there is the cost of transportation or delivery. It has a steel-plated, blast-resistant door. It comes painted, sealed, with magnesium anodes on the side that help to increase the corrosion resistance. We put a lifetime guarantee on the structural integrity. Ninety years. We'll build them in any size, any configuration.

"What I'm selling is not necessarily protection. What I'm selling is peace of mind. Whenever something big happens, it's going to be something that no one expected. Involve yourself in a regular, systematic, logical preparedness program to the point where you feel comfortable and then quit. Let it benefit you the way it should, let it ease your mind. That's the approach we take at Safecastle."

DAUGHTER ELEMENTS

"The flame spectrum of radium contains two beautiful red bands, one line in the blue-green, and two faint lines in the violet."

—Marie Curie

In the summer of 1914,

war stormed into Europe.

The French were now consumed by more pressing matters than sex scandals, and Marie returned to her adopted country, keen to aid in the war effort. She converted her savings to war bonds and volunteered to melt her Nobel medals for the cause, a service the bank officials declined to perform. To secure her reserve of radium from the invading army, she packed it in lead in a suitcase and boarded a train to Bordeaux.

"I was not able to carry it and waited in a public place, while a friendly ministry employee who came by the same train managed to find a room for me in a private apartment."

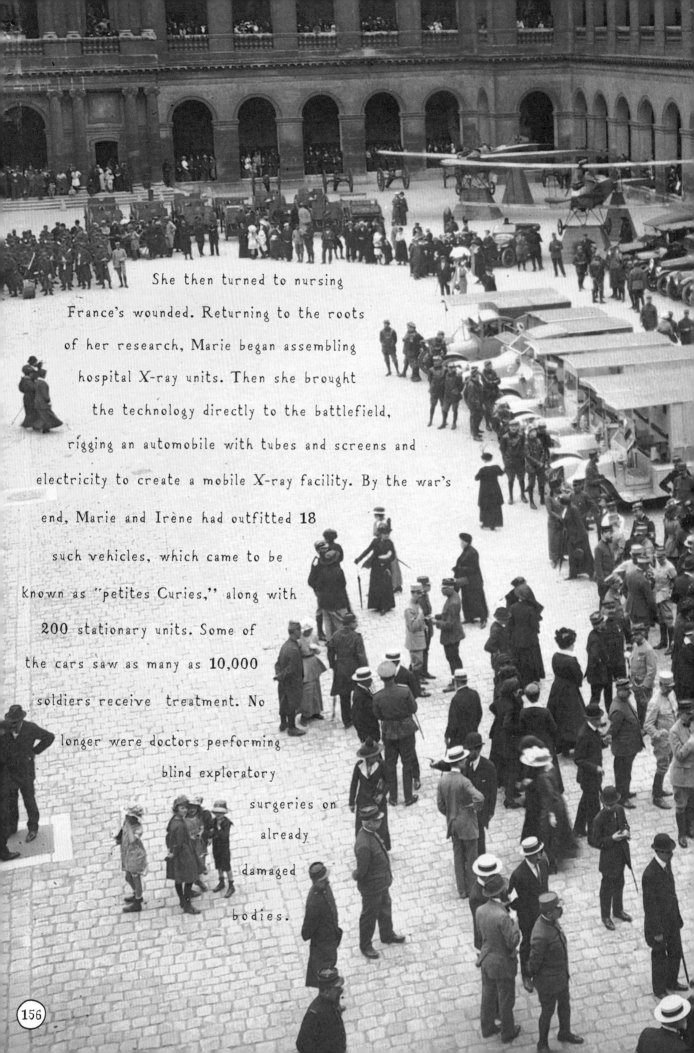

She then turned to nursing
France's wounded. Returning to the roots
of her research, Marie began assembling
hospital X-ray units. Then she brought
the technology directly to the battlefield,
rigging an automobile with tubes and screens and
electricity to create a mobile X-ray facility. By the war's
end, Marie and Irène had outfitted 18
such vehicles, which came to be
known as "petites Curies," along with
200 stationary units. Some of
the cars saw as many as 10,000
soldiers receive treatment. No
longer were doctors performing
blind exploratory
surgeries on
already
damaged
bodies.

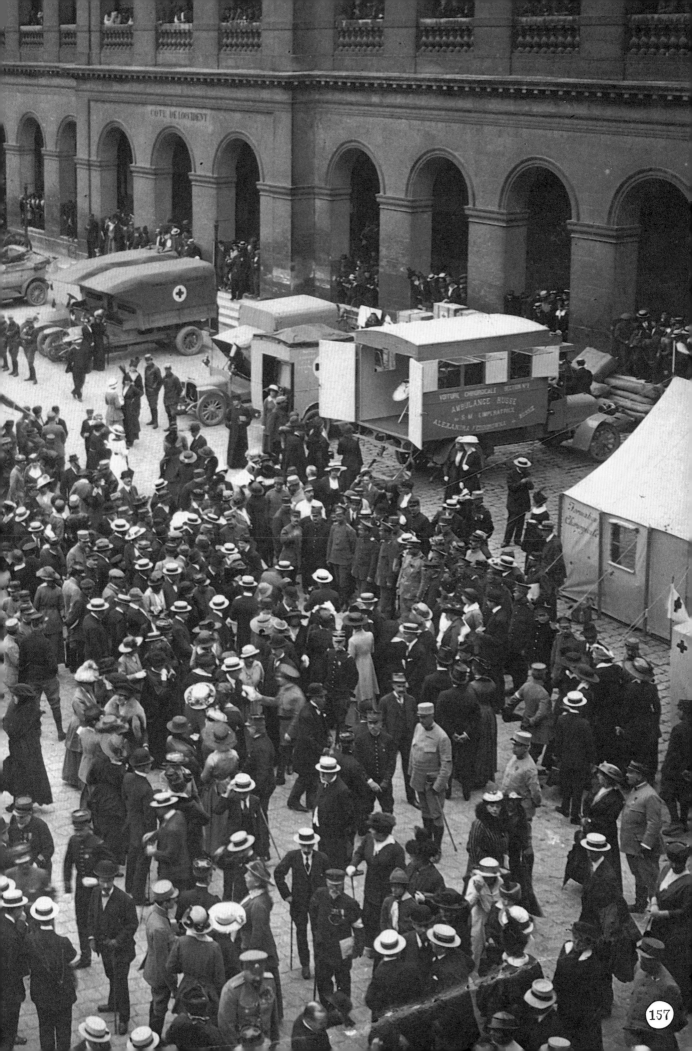

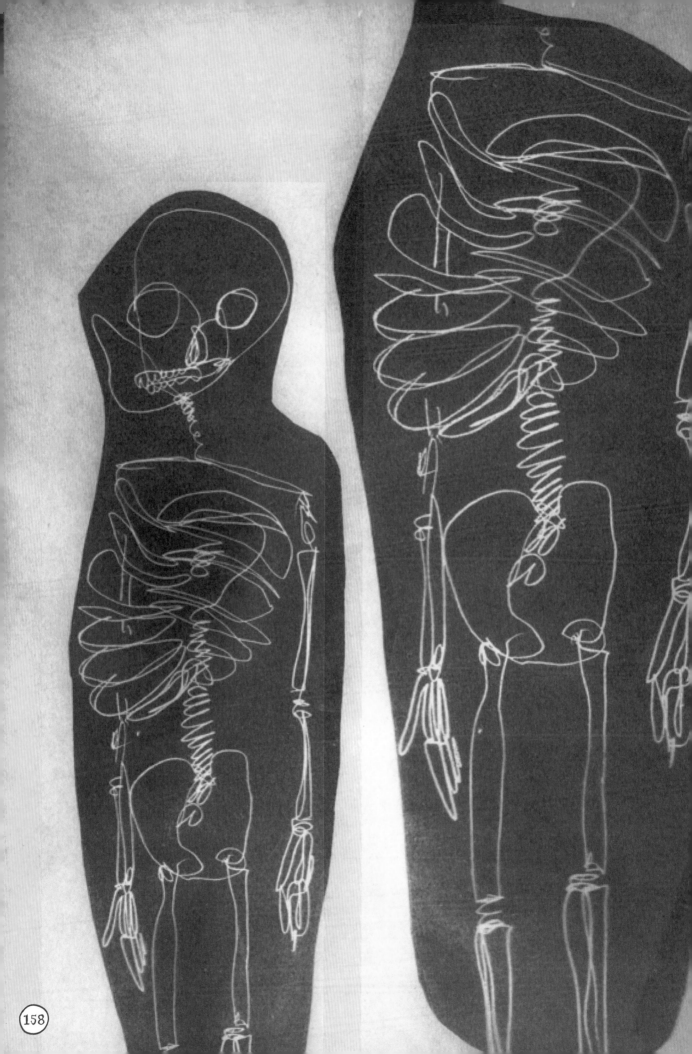

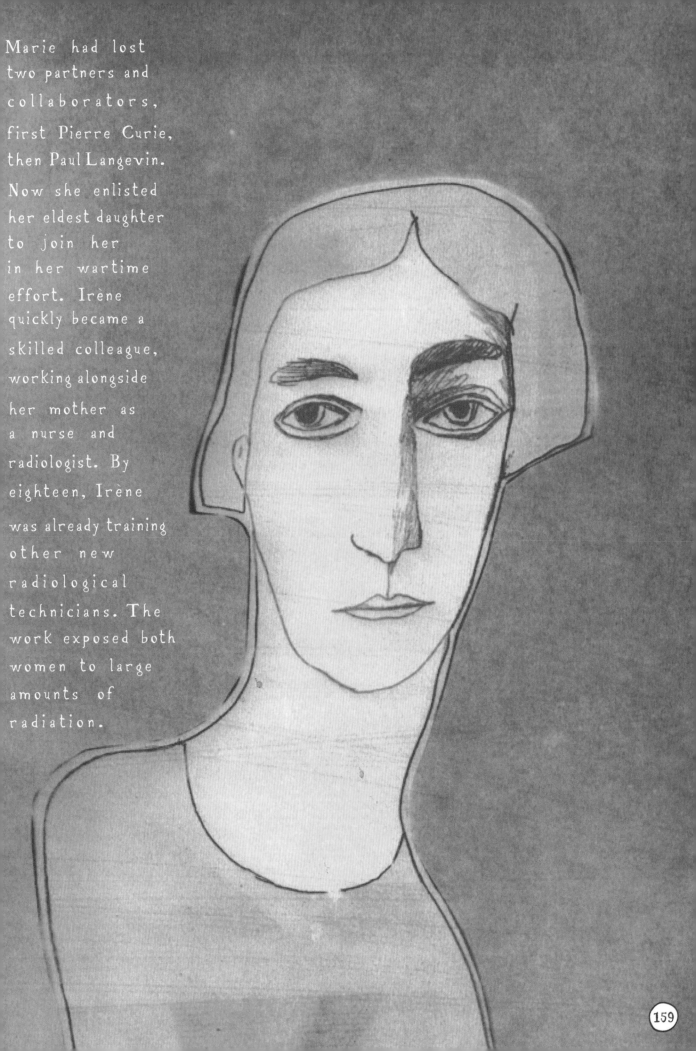

Marie had lost two partners and collaborators, first Pierre Curie, then Paul Langevin. Now she enlisted her eldest daughter to join her in her wartime effort. Irène quickly became a skilled colleague, working alongside her mother as a nurse and radiologist. By eighteen, Irene was already training other new radiological technicians. The work exposed both women to large amounts of radiation.

Radium lit up a war that was being fought at night. The marke
for luminous paint surged along with the demand for compas
dials, watches, gun sights, and other instruments that could b
used in the dark. But night was not the only cloak under whic
the enemy hid. German submarines, or U-boats, were provin
a deadly weapon against the Allies.

On May **17, 1915**, a German U-20
torpedoed the British luxury

ner RMS *Lusitania*, killing more than a thousand people. Many scientists worked on the roblem of submarine detection, but Paul Langevin was credited with the first effective ubmarine echo-location system — the detection of a hidden presence by its reflection of high requency sound waves, later dubbed "sonar" (SOund NAvigation and Ranging). The heart of the echnology was a piezoelectric device. In his most acclaimed achievement, Paul Langevin was again traveling a path paved by Pierre Curie. Even Monsieur Werlein, the skilled craftsman who cut for Langevin's work a crystal of unusually large dimension and perfect clarity, had come recommended by Pierre.

By the time of the armistice in **1918**, Marie had returned to the public eye. Scorned just a few years earlier as wayward and lustful, she was now regarded as a moral authority. Leaders of the French antiwar movement solicited her support. The nascent League of Nations appointed her to its Commission on Intellectual Cooperation.

Upon her arrival in New York in **1921**, she was showered with flowers, verse, and song. "Mme. Curie Plans to End All Cancers," the *New York Times* roared on its front page. A journalist inspired by her story helped raise **$100,000** to purchase a gram of radium for the Curie Institute. The money was presented to Marie by President Warren G. Harding at a White House ceremony.

She visited the Grand Canyon and Niagara Falls. She loved the landscape and observed the American character. Among her carefully recorded appointments and travel arrangements, she scribbled one curious yet charming note on a slip of white paper: "When three people hold up two fingers, that is the American sign 'Let's go swimming.'" She was feted at Carnegie Hall.

She was the guest of honor at dinners and luncheons, with one institution after another rolling out the red carpet and serving up delicacies: fruit cocktail and chicken à la Tyrolienne at the American Chemical Society, Mongol soup and sea bass in lobster sauce at the National Institute of Sciences. More taxing excursions were canceled though; her doctors worried the state of Marie's health was quite

precarious.

In 1929, her strength somewhat restored, Marie made a second trip to the United States, this time to receive a gift of $50,000 toward the purchase of a gram of radium for a new Radium Institute in Warsaw. She slept at the White House and dined with President Herbert Hoover, along with a countess, two astronomers, a paleontologist, a eugenicist, the president's personal physician, and the man who would later become head of Franklin Roosevelt's Uranium Committee (precursor to the Manhattan Project), Lyman Briggs. She took the night train to New York City and visited the zoo. Her meticulous thank-you notes document the many gifts she was given over the course of the trip. ("Please accept my thanks for your interesting book, *The Autobiography of a Fisherman*.") Marie pressed and brought back to Paris the red and white roses given to her by Lou Hoover, the First Lady.

Marie found fame unnerving. In a letter to Eve she wondered if there was any difference between the veneration she received and that accorded American boxing champion Jack Dempsey. "When they talk about my 'splendid work' it seems to me that I'm already dead — that I'm looking at myself dead." The more public recognition she received, the more private she became.

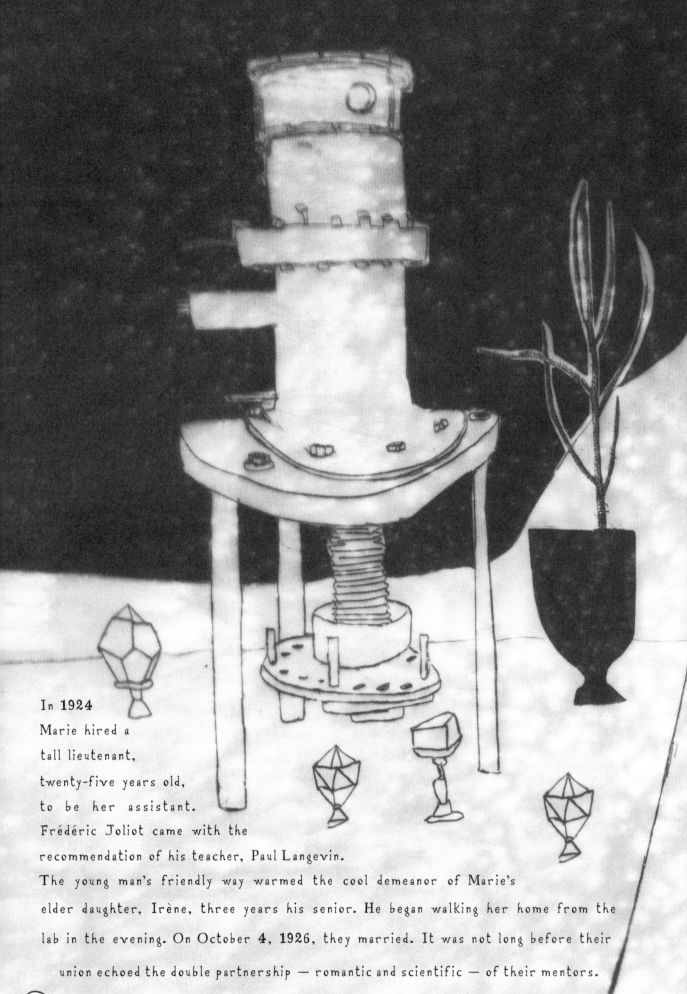

In 1924
Marie hired a
tall lieutenant,
twenty-five years old,
to be her assistant.
Frédéric Joliot came with the
recommendation of his teacher, Paul Langevin.
The young man's friendly way warmed the cool demeanor of Marie's
elder daughter, Irène, three years his senior. He began walking her home from the
lab in the evening. On October 4, 1926, they married. It was not long before their
union echoed the double partnership — romantic and scientific — of their mentors.

They combined their surnames to become Irène and Frédéric Joliot-Curie.

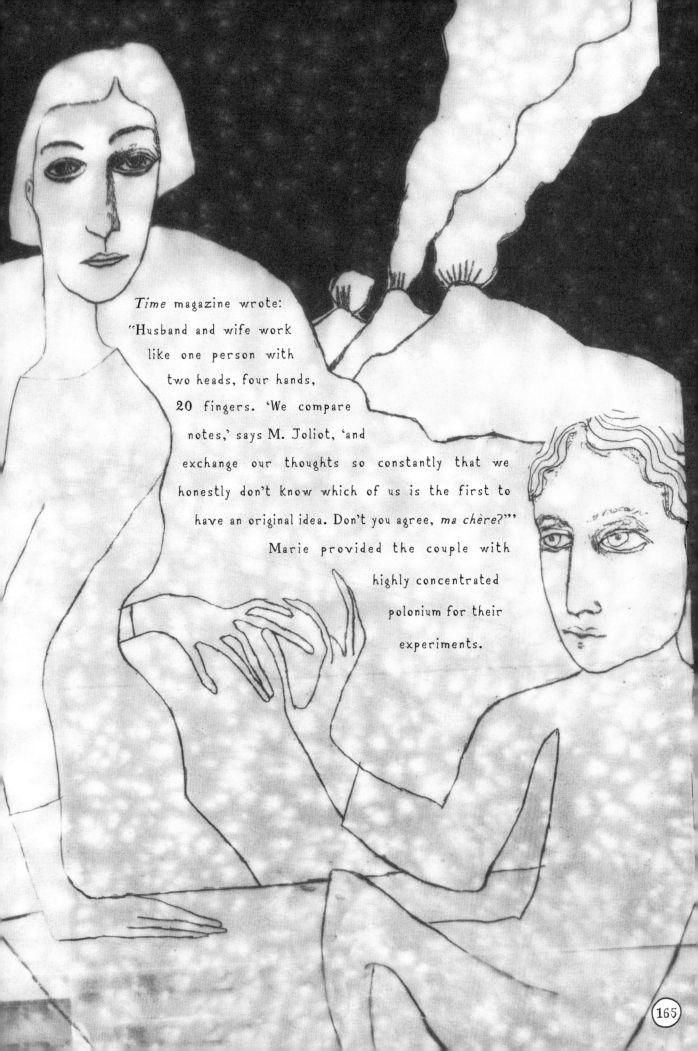

Time magazine wrote: "Husband and wife work like one person with two heads, four hands, 20 fingers. 'We compare notes,' says M. Joliot, 'and exchange our thoughts so constantly that we honestly don't know which of us is the first to have an original idea. Don't you agree, *ma chère?*'" Marie provided the couple with highly concentrated polonium for their experiments.

In 1927 Irène and Frédéric had a daughter, whom they named Hélène. Their second child, called Pierre for his maternal grandfather, was born in **1932**. In **1934**, bombarding aluminum with alpha particles, Irène and Frédéric transformed a naturally stable element into a radioactive one. They called this process "artificial radioactivity." They had discoverd that radioactivity could be provoked rather than simply observed. Perhaps humans could begin to harness the very invisible forces that had once seemed unknowable.

Though over time the capacity to produce nuclear reactions would hardly prove synonymous with control of their development or deployment, the Joliot-Curies had nevertheless made a discovery that, according to the *New York Times*, opened up "an entirely new realm of nature." Irène and Frédéric immediately recognized in their discovery a source of potentially limitless energy, a powerful medicine, and a tool for biological research. For the two scientists, however, both of them pacifists, the work would also have a more complicated legacy. "Mme Joliot-Curie and her husband made a definite contribution to studies that led to the development of the atomic bomb," wrote the *Times*.

In February 1939 Hungarian physicist Leo Szilard, later a top scientist on the Manhattan Project, wrote Frédéric asking him not to publish the results of his work on fission. Yet Frédéric would not abide such a prohibition, believing that scientific discoveries could not be possessed by their discoverers — neither in the form of a patent for profit, nor as military intelligence guarded by national loyalties. He went on publishing. Six months later, in August 1939, Szilard helped to ghostwrite a letter, signed by Albert Einstein, to President Franklin Roosevelt. "In the course of the last four months it has been made probable — through the work of Joliot in France as well as [Enrico] Fermi and Szilard in America — that it may become possible to set up a nuclear chain reaction in a large mass of uranium, by which vast amounts of

power and large quantities of new radium-like elements

would be generated…. This new phenomenon would

also lead to the construction of bombs, and

it is conceivable…that extremely powerful

bombs of a new type may thus be

constructed." Einstein urged FDR to

secure for the United States its

own supply of uranium and to

"speed up experimental work."

In other words, he begged the

president to make sure the Allies

had an atomic bomb before Hitler did.

As the pace of the research she helped set in motion

accelerated, and its consequences grew more alarming, Marie Curie herself was

slipping away.

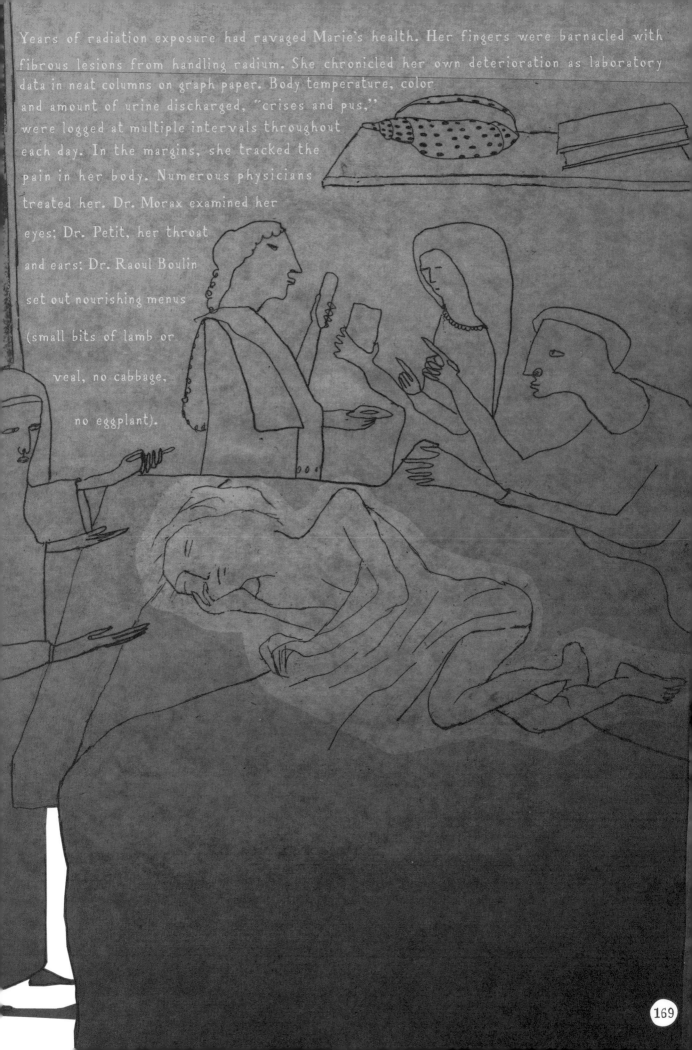

Years of radiation exposure had ravaged Marie's health. Her fingers were barnacled with fibrous lesions from handling radium. She chronicled her own deterioration as laboratory data in neat columns on graph paper. Body temperature, color and amount of urine discharged, "crises and pus," were logged at multiple intervals throughout each day. In the margins, she tracked the pain in her body. Numerous physicians treated her. Dr. Morax examined her eyes; Dr. Petit, her throat and ears; Dr. Raoul Boulin set out nourishing menus (small bits of lamb or veal, no cabbage, no eggplant).

One assistant described Marie's
presence in the lab as nearly
immaterial, "as if she could
walk through walls."
Wraithlike, a humming in her
ears, and her vision failing
after four cataract
surgeries, she felt her way
among her instruments and
through the rooms of her
laboratory. At dawn on
July 4, 1934, Marie Curie
passed away. The cause
of death was "aplastic
pernicious anemia" due to
prolonged radiation exposure.
She was sixty-six years
old. Her last words pulse
between lucidity and a dream
state: "I am absent.... I can no
longer express myself.... You
know, for this publication...
the paragraphs of the chapter
should be the same.... I don't
know if it's just because I
had a tremble, it's not the
medication, this would
have come anyway...."

The Merry Widow Health Mine, near Basin, Montana, is one of a number of former gold and silver mines in the United States that has been converted into a radon spa. Since 1952 more than two thousand people each year have come here to treat their arthritis, migraines, eczema, asthma, psoriasis, allergies, diabetes, depression and other ailments by breathing in air with radon levels of roughly thirteen hundred picoCuries per liter of air, more than three hundred times the dose-level deemed unsafe by the U.S. Surgeon General and the Environmental Protection Agency. But the Merry Widow's visitors swear by the mine's curative properties. Marianne and Bob Waller of Cut Bank, Montana, have made weekend trips since 2003.

MARIANNE WALLER: "I was in a car accident. I was diagnosed with liver failure due to hepatitis C from a blood transfusion."

BOB WALLER: "My wife was so sick; the doctors told us she probably had six months."

MARIANNE: "There are things they could do but the side effects are worse than what I've got."

BOB: "We were told about the mine and I said to Marianne, 'Let's get in the car and go. I didn't hesitate at all."

MARIANNE: "I've heard people say it causes cancer but I've never heard of anybody who's gotten it from going in there. And I was so bad I really didn't care. It's given me seven years longer than I expected."

BOB: "You just go in there and visit and you breathe in real small amounts of radon gas."

MARIANNE: "You walk into the side of the mountain."

BOB: "They recommend you do thirty-two one-hour visits a year. The way I understand it is that that's kind of a government deal because of the exposure to radon. In fact it's fine to stay in there longer, and Marianne and I, we are starting to do that. Every year we have increased our visits and every year Marianne has improved. We are doing almost one hundred hours a year in that mine."

MARIANNE: "They have a radiation counter you breathe into before you go in — it'll read zero — and when you come out you breathe into it and the needle swings up."

BOB: "The doctors can't believe it. I told her, don't even tell 'em. You know what happens: 'I don't want you going there anymore. You're going to get cancer.'"

MARIANNE: "Before we started, it would take me two to three hours, and sometimes four, just to do supper. I'd just give out. Now I have no problem. Some of my immune system has come back. The mine won't heal what I've got, but it has given me a way better quality of life. All I drink is the mine water. I thought, well, maybe I'm just convincing myself that I'm doing this good. But people see me and see how active I am, they just can't get over it."

BOB: "There is really something in that mine. I don't know how to describe it. We just know that it works."

MARIANNE: "Without Bob, I probably would have given up a long time ago. He has stuck right with me."

BOB: "When we started in 2003, Marianne's eyes were yellow and her skin was all jaundiced. She really, really looked sick. I didn't think she was going to be alive much longer. We went eight weekends in a row to the mine. I could see every weekend Marianne was getting a little more energy but she still looked real bad. Then probably around the sixth weekend we were there, we went down to the pizza place to have supper that Saturday night, I looked at her and I said, 'Marianne, your eyes are just sparkling.'"

A year and a half after Marie Curie's death, on November 14, 1935, her daughter and

son-in-law received word that they had won the Nobel Prize for their discovery of artificial radioactivity.

The following year, French president Léon Blum appointed Irène undersecretary of state for scientific research, a governmental position of unprecedented power for a woman. Frédéric joined the Socialist Party and worked on constructing a nuclear reactor that would generate energy through controlled fission reactions.

In 1940 the Germans marched into Paris. They placed a Nazi in charge of the Curie Institute. The Joliot-Curies hid their papers on fission in a bank vault. Frédéric joined the French Resistance under the pseudonym Jean-Pierre Caumont, and managed the extraordinary feat of smuggling 185 kilograms of heavy water to England.

Paul Langevin's early denunciations of the Nazis earned him the distinction of being the first French professor to be arrested by the Germans. He endured prison and surveillance until finally managing to escape to Switzerland. Frédéric secured him false identity papers, though Langevin refused to complete the disguise and shave off his mustache.

At the war's end France created the world's first civilian atomic energy authority. Frédéric Joliot-Curie was appointed director. Irène Joliot-Curie became chair of Nuclear Physics and Radioactivity at the Sorbonne.

In 1948, as head of the Atomic Energy Commission, Frédéric oversaw France's first nuclear reactor as it began operations on December 15, 1948. His daughter, Hélène, then seventeen, began her own career as a nuclear physicist working alongside her father.

As the cold war unfolded, secrecy and paranoia hovered over research. National militaries oversaw work that would have traditionally been sheltered by universities with the expectation of a free exchange of knowledge. In 1948 Irène traveled to the United States to give a series of speeches. Her host, Dr. Edward Barsky, had recently been interrogated by the House Un-American Activities Committee for his work with the Anti-Fascist Refugee Committee, found in contempt for refusing to turn over records, and sentenced to six months in jail. Irène's association with Barsky and and her husband's membership in the Communist Party caught the attention of American authorities. Upon touching down at LaGuardia Airport, she was seized and held overnight at Ellis Island. Frédéric, whose wartime devotion to France would have seemingly placed him beyond reproach, now also aroused suspicion. He made trips to Moscow and refused to work on the atomic bomb. In 1950 he was fired from his post at the Atomic Energy Commission.

The Joliot-Curies' work was also hamstrung by health concerns. Like Marie and Pierr

before them, Irène and Frédéric suffered from radiation exposure. They watched thei

health crumble as Marie's had. And like Marie, they, too, saw the next generation prepare

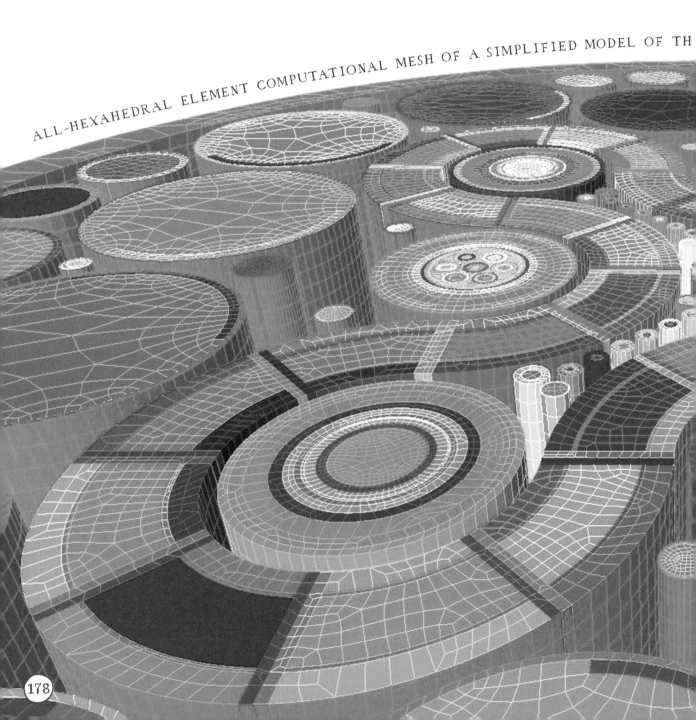

ALL-HEXAHEDRAL ELEMENT COMPUTATIONAL MESH OF A SIMPLIFIED MODEL OF TH

to pick up the relay. Their son, Pierre, became a biophysicist specializing in photosynthesis;

their daughter, Hélène, a nuclear physicist.

In 1948 Hélène, Marie's granddaughter, married a colleague,

scientist Michel Langevin, the grandson of Marie's former lover.

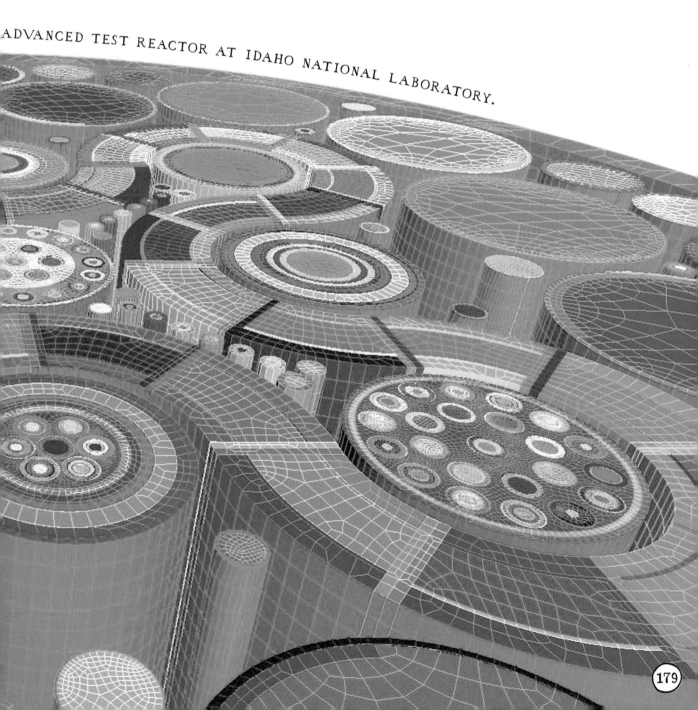

ADVANCED TEST REACTOR AT IDAHO NATIONAL LABORATORY.

For
many years, the
resilience of the human heart
has been debated. The prevailing
view has been that the heart is unable to
generate new muscle cells - that is, damage the
heart endures over a lifetime is irreparable. But
research obstacles have prevented definitive conclusions.
(In experimental animals, scientists might test the theory by
placing a radioactive tracer into heart cells and then tracking these
cells over time, but the introduction of such toxic materials into the body
makes this method out of the question for human subjects.) In 2007
Dr. Jonas Frisen, of the Karolinska Institute in Stockholm, Sweden, had an
epiphany. Atomic bomb tests during the cold war had caused a surge of radioactive
carbon-14 into the atmosphere. The radioactive carbon-14 was taken up by plants in
photosynthesis. These plants then became the world's harvest. People and animals ate the
plants and, because each year the level of radioactive carbon-14 in the atmosphere fell, each
year their cells developed a distinctive profile. A radioactive tracer, Dr. Frisen realized, had
been introduced into humans after all: the atomic tests conducted between 1945 and 1963 had time-
stamped the DNA of every human being on earth. The very experiments developed to vaporize
human existence would now be employed instead to understand and sustain life. Dr. Frisen's lab began
by studying the muscle cells of the left ventricle. Heart cells, they found, do regenerate.

DR. JONAS FRISEN: "In an old person, the heart muscle cells will be a mosaic: some that have been
with that person from birth, and there will be new cells that have replaced others that were lost."

A mosaic is also the metaphor cognitive scientist Douglas Hofstadter turns to in thinking about love
and the brain. In his book *I am A Strange Loop*, Hofstadter says that when you love someone and
know them intimately, you begin to hold a mosaic portrait of that person inside your head. The
better you know the person, the more finely-grained the mosaic portrait will be. Hofstadter
wonders if, following his wife's death, the deep empathy between them allowed him to think with
a grainy version of her brain inside his own.

DOUGLAS HOFSTADTER: "Over our many years together, through thousands of hours of casual
and intimate conversations, I had imported lower-resolution copies of the many experiences
central to her identity... Some of her memories were so vivid that they had become my own."

Indeed, even the word 'remember,' Hofstadter said in a telephone interview, "is not
strong enough. I feel like I was working extremely hard to carry out her desires, in
some sense, *be* her." The book goes on, "the key question is, no matter how much
you absorb of another person, can you have absorbed so much of them that when
that primary brain perishes, you can feel that that person did not totally
perish from the earth... because they live on in a 'second neural home'? ...
In the wake of a human being's death, what survives is a set of
afterglows, some brighter and some dimmer, in the collective
brains of those who were dearest to them.... Though the
primary brain has been eclipsed, there is, in those
who remain...a collective corona that still glows."

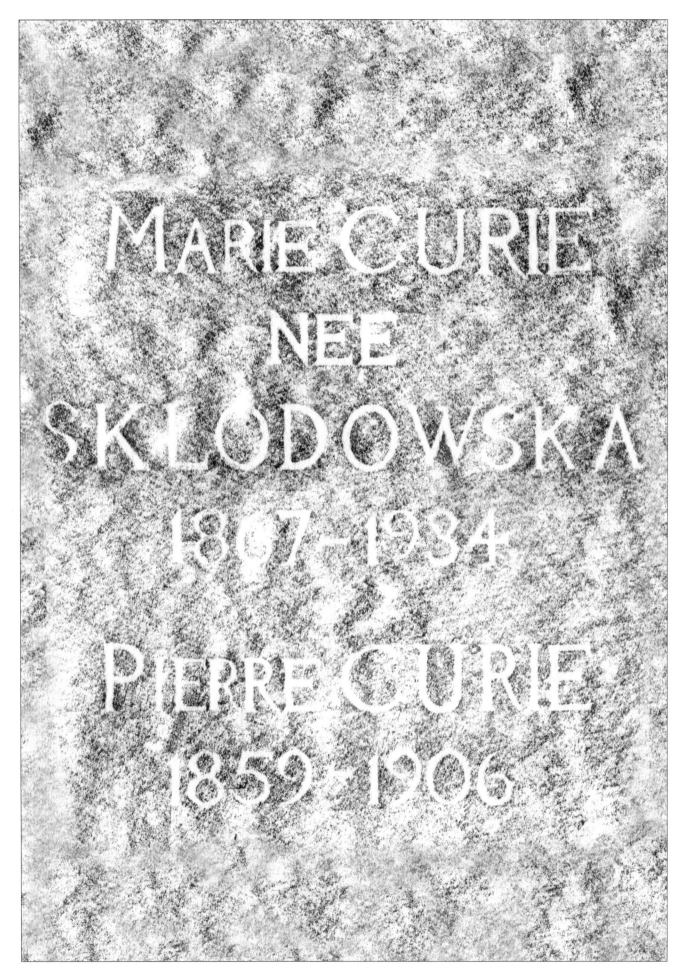

CHARCOAL RUBBING OF THE CURIE CRYPT IN THE PANTHEON, PARIS

Marie and Pierre reside today in Paris's resplendent necropolis, the Panthéon. Seventy-five people, some represented simply by an urn bearing their heart, are interred there, including Voltaire, Rousseau, Victor Hugo, Emile Zola, and Paul Langevin. Held in the Bibliothèque Nationale, the Curies' laboratory notebooks are still radioactive, setting Geiger counters clicking **100** years on.

Stamps and coins across the globe are emblazoned with likenesses of Curie family members. Streets, schools, subway stops, and holidays take their name. The "curie" was the first official measuring unit of radioactivity. Rare earth element atomic number 96 on the periodic table, synthesized at Berkeley in **1944**, is known as "Curium." On the far side of the moon are the Curie Crater, the Skłodowska Crater, and the Joliot Crater. There is a crater named for Marie on Mars, and the asteroid **7000** Curie orbits inside the asteroid belt between Mars and Jupiter.

Dr. Steven Howe is a nuclear engineer and the Director of the Center for Space Nuclear Research at the Idaho National Laboratory in Idaho Falls. Some of his work is available to the public, some is classified. He has researched nuclear rocket propulsion, hyper-velocity aerodynamics and thermodynamics, non-equilibrium X-ray emission, antimatter physics, and hypersonic flight.

NORTH KOREAN STAMP
COMMEMORATING
50TH ANNIVERSARY
OF THE DEATH OF
MARIE CURIE

DR. STEVEN HOWE: "Nuclear power and propulsion will be the key technology that enables humans to explore space. There are three major categories. The most mature is Radioisotopic Thermoelectric Generators — RTGs. Space batteries. RTGs depend on radioactive decay. Plutonium-**238** decays and creates heat. That heat creates electricity. Every deep space mission past Mars has had an RTG. The half-life of plutonium **238** is eighty-seven years, so those things are still cranking out power on the moon. There are other isotopes we can use beside plutonium. One of those is strontium **90**. We have a great deal of it from the nuclear weapons program and reprocessing of reactor fuel. We are looking at using either strontium or plutonium as a heat source in a turbo jet to fly an airplane on any planetary body that has an atmosphere. You could suck in the atmosphere, blow it out the back and push yourself along. Based on the long half-life of the isotope, you can fly for years. If you see a glinty thing on the horizon, you can fly over and see it. The next category is human missions. You are going to need nuclear power for electricity to support the lunar outposts, to support the astronauts on the lunar or Martian surface. Right now there is an effort to develop what is called a Fission Surface Power system — an FSP — for the lunar surface. These are power reactors. It would give you about **40** kilowatts of power and have a long life of about seven or eight years. It wouldn't matter if it were day or night. Category three is transportation and rockets. In the long term, the vision is humanity expanding into the solar system. In a hundred years, we are going to have cities on the moon. Once we have the ability to get from the earth's orbit to the lunar surface, you allow pioneer types to go. There are tremendous resources on the moon — lots of metals, lots of oxygen, lots of sulfur. Lunar dust is a unique material. Think of very tiny particles of sharp glass that are about a micrometer or a few micrometers in size. You could use microwave processing to make roads. You might be able to look up and see a network of highways and roads and landing pads. You can turn lunar dust into glass and make glass bricks. The bricks will stop the galactic cosmic radiation and let sunlight through. You'd have greenhouse capability. You could have glass cities and glass roads. A crystal city."

NOTES

Unless otherwise noted, all chapter epigraphs come from Marie Curie's doctoral thesis: Marie Curie, *Recherches sur les Substances Radioactives* (Paris: Annales de Chemie et de Physiques, 1903).

"Curie Archives" refers to the collection of Marie and Pierre Curie's papers held at the Bibliothèque Nationale (Richelieu), Paris, France. "NAF" stands for Nomenclature d'Activités Française.

CHAPTER 1: SYMMETRY

6. "I can't let my head go with every breeze": Curie Archives, microfilm 2676.

"paper on heat waves": Marie Curie, *Pierre Curie* (New York: Macmillan, 1923), 46.

7. "Eye of the Sea...wild strawberries": I've collapsed here a year of Marie's travels between ages 15 and 16.

"locked up in an asylum for the insane": Eve Curie, *Madame Curie* (New York: Da Capo Press, 2001), 43.

8. "vowed...to lead a priest's existence": Curie Archives, microfilm 2676.

"for an hour of love": Ibid.

9. "slugs which haunt the dirty water of our river": Eve Curie, *Madame Curie*, 79-80.

10. "I did not regret": Curie Archives, microfilm 2676.

11. "fling myself into the greatest follies": Eve Curie, *Madame Curie*, 79-80.

"my head is so full of plans that it seems aflame": Ibid, 82.

CHAPTER 2: MAGNETISM

24. "Pierre heated up various materials": Marie Curie, *Pierre Curie* (New York: Macmillan, 1923), 66.

25. "The room I lived in": Ibid, 170.

26. "stability with colorific splendor": *Nobel Lectures, Physics 1901-1921* (Amsterdam: Elsevier Publishing Company, 1967).

27. "dreamer absorbed in his reflections": Marie Curie, *Pierre Curie*, 173.

"a conversation which soon became friendly": Ibid, 74.

30. When we met in Paris in January 2007, Hélène Langevin-Joliot, the granddaughter of Marie and Pierre Curie, said to me, "There are two traps when writing a biography of the Curies. One: to turn their story into a fairy tale. Two: to forget Pierre." After our meeting I reflected on her warning. I have willfully blundered into the first trap, but taken pains to avoid the second.

"meter readers and pneumatic dampeners": Marie Curie, *Pierre Curie*, 63.

"smoke detectors.... medical ultrasound": Telephone conversation with Rob Carter, President, Piezoelectric Systems, Inc., Cambridge, Mass., May 21, 2008.

33. "asked me to share that life": Marie Curie, *Pierre Curie*, 75.

"butting his head against a stone wall": Eve Curie, *Madame Curie*, 132.

"our scientific dream": Marie Curie, *Pierre Curie*, 76.

"cannot endure the idea of separating": Susan Quinn, *Marie Curie: A Life* (New York: Simon & Schuster, 1995), 124.

34. "which forever rages at them": Marie Curie, *Pierre Curie*, 84.

CHAPTER 3: FUSION

42. "César Becquerel, had studied phosphorescent minerals.... Edmond, ultraviolet light": J.L. Basdevant, *Henri Becquerel à l'aube du XXe siècle*, (Editions de l'Ecole Polytechnique, 1996), 15.

44. "The very foundation of modern chemistry": Marie Curie, "Radium and Radioactivity," *Century Magazine* (January 1904): 461-66.

"What was the structure of the atom?... Could this energy be harnessed?": "Radioactivity opened up the way to the exploration of the atom, then of the nucleus. Rutherford discovered the nucleus in 1911, and transmutations (nuclear reactions) in 1919. These results and many others prior to the Second World War could not have been achieved but for the use of alpha particles. These swift and heavy particles played the role of

our modern accelerator beams for probing matter at a microscopic level. In the 1930s polonium sources became especially popular, due to their monoenergetic alpha particles, for studying transmutation processes. They were used in the experiments leading to the discovery of the neutron by J. Chadwick in 1932 and in the experiments by F. and I. Joliot-Curie leading to the discovery of artificial radioactivity.... The concept of isotopes emerged as a result of the development of radiochemistry, soon followed by the discovery of the tracer method. In the first decade of this century, radium began to be used as a source of ionizing radiation for medical purposes." Hélène Langevin-Joliot, "Radium, Marie Curie and Modern Science," *Radiation Research*, 150, no. 5, Supplement, Madame Curie's Discovery of Radium (1898): A Commemoration by Women in Radiation Sciences (November 1998), S3-S8). An atom is the smallest unit of an element that retains the characteristics of that element. An element is composed of many of one type of atom.

"a new science was in the course of development": Marie Curie, *Nobel Lectures, Chemistry 1901-1921* (Amsterdam: Elsevier Publishing Company, 1966).

47. "I coined the word *radioactivity*.": Marie Curie, *Pierre Curie*, 96.

CHAPTER 4: WHITE FLASH

52. "universal fluid...V-rays": Clément Chéroux, *The Perfect Medium: Photography and the Occult* (New Haven: Yale University Press, 1995), 116, 119.

In Stanley Kubrick's *Dr. Strangelove*, General Jack Ripper is clutched with a paranoid fixation that the Soviets are infiltrating American "vital fluids" through water fluoridation, leading him to launch a nuclear war. His preoccupation recalls Spiritualist descriptions of "ectoplasm" — the physical manifestation of psychic energy — a viscous and gravity-defying cloud that was said to be seen emanating from the mouth of a medium.

53. on Sâr Dubnotal: Jean-Marc and Randy Lofficier, *Shadowmen: Heroes and Villains*

of French Pulp Fiction (Hollywood: Black Coat Press, 2003), 273.

"from a scientific point of view": Curie Archives, NAF 18434.

"no possible deception": Curie Archives, NAF 18515.

54. "seemed abnormal": Marie Curie, *Pierre Curie*, 97.

55. "she decided to test a found sample": Interview with Anna Hurwic, Paris, July 2008. See also, Quinn, 148-49.

"second unknown ingredient": In his book *Marie Skłodowska-Curie et La Radioactivité*, Jozef Hurwic describes an additional insight that would have further burnished the Curies' legacy, had it not been for its low-key pronouncement and subsequent retraction. In 1900 in *La Revue Scientifique*, a journal with a small circulation, Marie wrote: "Radioactive material is not in an ordinary chemical state; the atoms are not constituted by a stable state because particles smaller than the atom are radiated. The atom from a chemical point of view indivisible is divisible here and the sub-atoms are in motion. Radioactive material shows a chemical transformation that is the source of radiated energy; but it is not an ordinary chemical transformation, because ordinary chemical transformations leave the atom indivisible. In radioactive matter, something changes, and it is certainly the atom, because the radioactivity is tied to the atom." The Curies subsequently disavowed this theory, and offered instead the idea that a radioactive element pulls in its energy from some mysterious outside force. Then, in 1902, Ernest Rutherford and Frederick Soddy with their own experiments proved indeed that atoms are divisible, and that in emitting radioactivity one element spontaneously transforms into another. From that point forward, Rutherford was considered "the father of nuclear physics."

"the Latin word for *ray*": David I. Harvie, *Deadly Sunshine* (Stroud: Tempus, 2005), 38.

57. "one tenth of a gram of radium chloride": Harvie, *Deadly Sunshine*, 39-44.

"excitement of actual progress": Marie Curie, *Pierre Curie*, 187.

"letters scripted directly one atop the other": assorted laboratory notebooks, Curie Archives.

9. "as complete as that of a dream": Marie Curie, *Pierre Curie*, 104.

0. "faint, fairy lights": Ibid, 187.

1. "Anemia...Sexual Decline": Hugo Gernsback, "Radium: Boon or Menace," *Science and Mechanics*, 6 (June 1932): 614-16, 676-78.

"a horror to heighten horror": Robert Louis Stevenson, "A Plea for Gas Lamps," in *The Travels and Essays*, 13 (New York, 1917), 168-69. Cited in Wolfgang Schnivelbusch, *Disenchanted Night: The Industrialization of Light in the 19th Century* (Oxford: Berg Publishers Ltd, 1988), 134.

"the light of the living oil lamp conjured up": Gaston Bachelard, *La Flamme et une Chandelle* (Paris: Presses Universitaire de France, 1961), 90. Cited in Schnivelbusch, 178.

chemical composition of Undark paint: Harvie, *Deadly Sunshine*, 165.

"like soft moonlight": Sabin von Sochocky, "Can't you find the keyhole?" *The American Magazine* (January 1921). Cited in Harvie, *Deadly Sunshine*, 166.

4. "in touch with the supernatural": Loïe Fuller Notebooks and Letters (1907-1911), Jerome Robbins Dance Division, New York Public Library.

6-67. Multiple foreign occupations over a turbulent history make it difficult to clearly define what and who can be clearly identified as Polish. The bounds of Marie Curie's Poland would have been more restricted than the list here implies. For instance, Jews, conducting their lives in Yiddish would not likely have been a part of her conception of her country and culture. Other esteemed and mobile persons noted here, including Frédéric Chopin, are, like Marie Curie, claimed by both their native and adopted countries.

CHAPTER 5: INSTABILITY OF MATTER

70. "To his joy, a lesion appeared": Eve Curie, *Madame Curie* (New York: Da Capo Press, 2001), 198.

"indicating a deeper injury": Anna Hurwic, *Pierre Curie* (Paris: Flammarion, 1995), 234.

71. "I couldn't breathe": Telephone interview with Daniel Fass, October 2008.

72. "joined the Curies for dinner": Susan Quinn, *Marie Curie: A Life* (New York: Simon & Schuster, 1995), 183.

73. Particularly following her receipt of the Nobel Prize, Marie Curie's archives are full of elegant certificates, invitations, and awards from heads of state and major institutions. Time and time again, the engraved "Monsieur" on a standardized form is crossed out in favor of a hand-written "Madame."

74. "suffered a miscarriage": Curie Archives, NAF 18515.

"cannot be consoled": Marie Curie, letter to Bronya, August 25, 1903, aig.org.

"very feeble capacity for work": Curie Archives, NAF 18515.

"completely isolated": Eve Curie, *Madame Curie*, 196.

75. "scarcely ever separated": Marie Curie, *Pierre Curie*, 82.

76. "Well, it has not been easy": Ibid, 196.

"disfigured right hand": Kai Bird and Martin Sherwin, *American Prometheus: The Triumph and Tragedy of J. Robert Oppenheimer* (New York: Vintage, 2005), 11.

77. "Irving S. Lowen was a theoretical physicist": For an account of the Lowen affair, see Joseph Lash, *Eleanor and Franklin* (New York: W.W. Norton & Co, 1971), 704-7.

"My grandfather was goaded into a sacrificial mission": Conversations with Cynthia Lowen, New York City, 2007 and 2008.

"a message came that the Germans": The message came through Fritz Houtermans;

see Lash, *Eleanor and Franklin*, 704.

"Irving was chosen": This is contradicted by Lash, who says Lowen "volunteered to go to her not as a representative of the worried scientist's, but on his own." Ibid, 705.

"his own anxiety": Ibid, 705.

"because of military red tape": Ibid, 706.

"I fear...that he talks too much"": Ibid, 707.

81. Map of Hiroshima: "Atomic Bomb Damage Status," *Hiroshima Atomic Bomb Disaster* (Hiroshima: Hiroshima City Office, 1971), appendix.

83. "At the time, I lived with my parents": Interview with Sadae Kasaoka, Hiroshima, Japan, April 2008.

87. "there was no night": Curie Archives, NAF 18515.

CHAPTER 6: HALF-LIFE

90. "250 dials a day": David I. Harvie, *Deadly Sunshine* (Stroud: Tempus, 2005), 167.

"glowed as if lit from within": Ibid, 173.

"Doom Book": "Radium Poisoning Kills 16th Victim," *New York Times*, (September 5, 1930).

"little, tiny nuclear bomb": Alan Cowell, "London Riddle: A Russian Spy, a Lethal Dose" *New York Times* (November 25, 2006).

"Let's say for example": Interviews with Ed Epstein, New York, 2007 and 2008.

94. "sweet days under a mild sun": Marie Curie, *Pierre Curie* (New York: Macmillan), 137.

94-95. "We collected flowering chestnut branches...nothing troubled us": Curie Archives, microfilm 4300. Parts of Marie Curie's diaries here have been redacted. Reading along the particularly raw sections in which she writes of losing Pierre, one comes across lines of handwritten text that have been cut clean out of the pages.

96. "the brain of Pierre Curie": Eve Curie,

Madame Curie (New York: Da Capo Press, 2001), 245.

102. "normal accident": Charles Perrow, *Normal Accidents: Living with High-Risk Technologies* (Princeton: Princeton University Press, 1999), 4.

"serious when they interact..." Ibid, 7. changed the verb tense in this sentence. Original text reads "interacted."

105. "flowers...on the table": Curie Archives, microfilm 4300.

"still ticked": Ibid.

106. "that big deep hole": Ibid.

CHAPTER 7: ISOLATION

110. "some imbeciles to congratulate me on it": Curie Archives, microfilm 4300.

113. At Hiroshima, the bomb's tremendous blast and heat rays had caused intense devastation but did not leave vast amount of residual radiation. By contrast, at Chernobyl, while the initial explosion was less violent, it released some 100 to 400 times more fallout, tons upon tons of radioactive contamination.

114-15. Situational map of Chernobyl, V. M. Shestopalov. *Atlas of Chernobyl Exclusion Zone* (Kiev: Ukrainian National Academy of Science, 1996), 26.

116. Telephone interviews with Tim Mousseau, 2007 and 2008.

CHAPTER 8: EXPOSURE

123. "I spent last evening": Gustave Téry, "Pour une Mère," *L'Oeuvre* (Paris, 1911), 14.

"I kiss you tenderly awaiting tomorrow" "France Divided on Curie Case," *New York Times* (November 28, 1911).

125. "where Pablo Picasso would later paint *Les Desmoiselles d'Avignon*": Julien Bob and Catherine Kounelis, "Paul Langevin (1872-1946)," *Europhysics News*, 38, no. 1 (January-February 2007), 19. Description of the Bateau Lavoir: Dan Franck, *Bohemian Paris: Picasso, Modigliani, Matisse, and the Birth of Modern Art* (New York: Grove Press, 1998), 54.

Details on Paul's childhood: André Langevin, *Paul Langevin, Mon Père* (Paris: Les Editeurs Français Réunis, 1971), 18.

"thesis on ionized gases": Bok and Kounelis, "Paul Langevin (1872-1946)," 19.

"if it had not been done elsewhere": Ibid, 52.

28. "latent hostility": Téry, "Pour une Mère," 11.

"poorly cooked compote": Susan Quinn, *Marie Curie: A Life* (New York: Simon & Schuster, 1995), 298.

"whacked him in the head": Ibid, 262.

"threatened to kill her": Ibid, 263.

"my position and my life": *New York Times* (November 28, 1911).

129. "lessons if you like": Téry, "Pour une Mère," 23.

130. "What we are developing is a video-based surveillance system": Telephone interview with Dr. Mongi Abidi, November 2007.

"don't become really harmful until they are exploded": Well, sort of. Stockpiling nuclear weapons, even as a deterrent, demands nuclear "preparedness." This implies, among other things, a heavy financial burden and a significant health hazard as a result of nuclear testing's poisonous effect on the environment.

131. For the story of Roger Ray's pinhole camera, see "Scientist Snaps Bomb Blast With 'Dixie Cup' Camera," *Denver Post*, January 6, 1957.

132. "withheld the stolen letters": For their accounts of the so-called Affair Langevin, in addition to contemporary newspaper accounts and Gustave Tery's "L'Ouevre," which includes a scathing indictment of Marie as well as the publication of a number of letters between Paul and Marie, I am particularly indebted to Susan Quinn's *Marie Curie: A Life* and Karin Blanc's *Marie Curie et le Prix Nobel* (Uppsala: Uppsala Studies in the History of Science, 1999).

133. "adulterous relations with a concubine": Téry, "Pour une Mère," 11.

"greatest sensation in Paris since the theft of the Mona Lisa": "World Famous Scientist Reported Involved in Love Romance: Rival Wife Begins Suit," *Chicago Daily Tribune* (November 5, 1911).

"plunder it, soil it, dishonor it": Téry, "Pour une Mère," 4.

"liberated woman": Ibid, 8.

"before it was discovered by Pierre Curie": Ibid, 10.

"who could have her at their table": Karin Blanc, *Marie Curie et le Prix Nobel*, 102.

"absolutely without foundation": Ibid, 113-14. (Svante Arrhenius was also one of the people who had nominated Marie for her second Nobel Prize.)

135. "There is no connection between my scientific work and the facts of private life": Quinn, *Marie Curie*, 328.

"Leave it to the vipers it was fabricated for": Translation: Ibid, 310. In the original German: *The Collected Papers of Albert Einstein*, 8A (Princeton: Princeton University Press, 1998), 7.

Paul Langevin also wrote a letter to Svante Arrhenius to defend Marie, in which he says the letters were "reproduced in a form twisted by alterations and edits" and that she is being "crucified" for her efforts to help rescue Paul from a destructive situation in order to save his "scientific future." Blanc, *Marie Curie et le Prix Nobel*, 121.

136. "flames which were destroying her hometown": "World Famous Scientist Reported Involved in Love Romance: Rival Wife Begins Suit," *Chicago Daily Tribune* (November 5, 1911).

138. Another some one thousand bombs have been detonated in other nuclear tests worldwide.

"I'm a mining engineer": Interviews with Bill Flangas, Las Vegas, Nevada, February 2008, and by telephone December 2007 and May 2008.

140. "The first vivid memory": Telephone conversations with Preston Truman, February 2007 and May 2008.

145. "deprive French science of a precious brain": Quinn, *Marie Curie*, 326.

"I am not an assassin": Ibid, 325-26

146. "eleven-course dinner": Blanc, *Marie Curie et le Prix Nobel*, 168.

147. "love affair, also with a married man": Edward Burton, "Nordstjernan's Father Complex: The Swedish-American Press and the Haijby Affair," *Swedish-American Historical Quarterly*, 53, no. 1 (January 2002): 30-56.

148. Information on the settlement: *New York Times*, December 21, 1911. According to André Langevin's biography of his father, Paul and Jeanne Langevin reconciled following World War I. Langevin, *Paul Langevin*, 87.

"rushed on a stretcher": Quinn, *Marie Curie*, 332.

"she drew up a will": Ibid.

"Ayrton studied ripple effects": Hertha Ayrton, "The Origin and Growth of Ripple-Mark", *Proceedings of the Royal Society of London*, Series A, 84, no. 571 (October 1910), 285-310.

"We provide not only storm and fallout shelters": Telephone interview with Vic Rantala, January 2007.

CH. 9: DAUGHTER ELEMENTS

155. "a service the bank officials declined to perform": Susan Quinn, *Marie Curie: A Life* (New York: Simon & Schuster), 361.

"find a room for me in a private apartment": Marie Curie, *Pierre Curie* (New York: Macmillan, 1923), 207.

156. "18 such vehicles": Quinn, *Marie Curie*, 336.

160. "compass dials, watches, gun sights": David I. Havie, *Deadly Sunshine* (Stroud: Tempus, 2005), 129.

161. "Monsieur Werlein": André Langevin, *Paul Langevin, Mon Père* (Paris: Les Editeurs Français Réunis, 1971), 81.

162. To be sure, some were still reluctant to recognize the achievements of a woman: there was behind-the-scenes dissent at Yale, Harvard voted against granting Marie an honorary degree, and the National Academy of Sciences also declined to elect her a member.

"Let's go swimming": Curie Archives, microfilm 2666.

"fruit cocktail...sea bass": Ibid.

Marie Curie's medical records: Ibid.

163. "your interesting book": Curie Archives, microfilm 2667.

"red and white roses": Dale C. Mayer, *Lou Henry Hoover: A Prototype for First Ladies* (Hauppauge: Nova Publishers, 2003), 24.

"that I'm looking at myself dead": Eve Curie, *Madame Curie*, 347.

165. "'Don't you agree, *ma chère?*'": "Science: Artificial Radioactivity," *Time* (February 12, 1934).

166. "an entirely new realm of nature": "Joliot-Curie Dies; French Physicist, Famed Nuclear Scientist," *New York Times* (August 15, 1958). The Joliot-Curies' achievement masked two earlier failures — "failures" at least, according to the protocol of recognition in the scientific world. Though they were unable to fully interpret the implications of their own data, their work was critical to two major discoveries apart from the work for which they won the Nobel Prize. First, the Joliot-Curies did everything but realize that through their experiments they could have discovered the neutron, the particle capable of provoking a chain reaction and thereby releasing energy from matter. (British physicist James Chadwick would pick up the research and make the critical observation in 1932.) Later, the insights key to the discovery of nuclear fission similarly eluded them. Still, the work of the Joliot-Curies was central to unlocking the power of the atom. Their work would not have been possible without resources uniquely at their disposal: the world's strongest source of polonium (emitter of alpha radiation) and, frail but

still formidable, Marie Curie herself.

"the development of the atomic bomb": "Mme Joliot-Curie Is Dead in Paris," *New York Times* (March 18, 1956).

7. "Szilard...wrote Frédéric": Pierre Biquard, *Frédéric Joliot-Curie, The Man and His Theories* (Greenwich: Fawcett Publications, Inc,. 1962), 45.

9. Marie Curie's medical records: Curie Archives.

1. "as if she could walk through walls": "The First Great Woman Scientist — And Much More," *New York Times* (December 3, 1967).

"Humming in her ears": Eve Curie, *Madame Curie*, 371.

"aplastic pernicious anemia": Curie Archives, microfilm 2674.

"this would have come anyway": Ibid.

2. "More than two thousand people": Estimate provided by Elizabeth Kelly, the manager of the Merry Widow Health Mine, no precise count available.

"I was in a car accident": Telephone interview with Marianne and Bob Waller, April 2008.

6. "controlled fission reactions": "Frédéric Joliot: The Nobel Prize in Chemistry 1935," *Nobel Lectures, Chemistry 1922-1941* (Amsterdam, Elsevier Publishing Company, 1966).

"in a bank vault": Barbara Goldsmith, *Obsessive Genius: The Inner World of Marie Curie* (New York: W.W. Norton and Company, 2005), 226.

"under the pseudonym Jean-Pierre Caumont": Robin McKown, *She Lived for Science: Irène Joliot-Curie* (New York: Julian Messner, 1961), 148.

"shave off his mustache": André Langevin, *Paul Langevin*, 208.

"seized and held overnight": "Mme Joliot-Curie Detained at Ellis Island on Her Arrival," *New York Times* (March 19, 1948).

0. "resilience of the human heart": Nicolas Wade, "Heart Muscle Renewed Over Lifetime, Study Finds," *New York Times* (April 3, 2009).

"In an old person": Telephone interviews with Dr. Jonas Frisen, May and August 2009.

183. "Nuclear power and propulsion": Telephone interviews with Steven Howe, January and May 2008.

RADIOACTIVE BESTIARY AND GARDEN

SPIDER-MAN: high school student Peter Parker who gains superhuman strength, bullet-dodging dexterity, and the ability to cling to any surface and to spin a web after being bitten by an irradiated spider.

GODZILLA: Japanese monster created by hydrogen bomb fallout.

THE HULK: nuclear physicist Dr. Robert Bruce Banner transformed by gamma radiation from an underground nuclear test into a brutish green menace with phenomenal strength, the ability to breath underwater, and anger issues.

COCKROACH: mythologized as the lone survivor of a nuclear holocaust.

DEINOCOCCUS RADIODURANS ("Deinococcus": strange berry; and "radiodurans": resistant to radiation): bacterium discovered in Oregon in 1956 as a contaminant in cans of meat blasted by radiation. According to scientist Michael Daly of Uniformed Health Services in Bethesda, Maryland, not cockroaches, as often cited, but this bacteria would be the last living organism to survive a nuclear catastrophe. His research on the astonishing resilience of Deinococcus may point to new ways to protect human beings from radiation exposure.

HORSE AND CARRIAGE THAT KILLS PIERRE CURIE (See page 97.)

BERT THE TURTLE: anthropomorphic cartoon reptile from cold war *Duck and Cover* Civil Defense films.

ALBINO BARN SWALLOWS: birds adapting to radioactive contamination in Chernobyl's Zone of Alienation. (See page 117.)

IVORY ELEPHANT: gift to Marie Curie from U.S. President Herbert Hoover, 1929. (See page 163.)

WATER BUTTERCUPS (Ranunculus aquatilis): flowers gathered by Pierre Curie, April **18, 1906**, still fresh after his sudden death the following day. (See pages **94, 102.**)

MUTANT FLOWERS: collected by Mary Osborn after the Three Mile Island nuclear plant accident, March **28, 1979**, Harrisburg, Pennsylvania (See pages **102-103.**)

ZINNIA ROSE

BRAZIL NUTS: world's most naturally radioactive food.

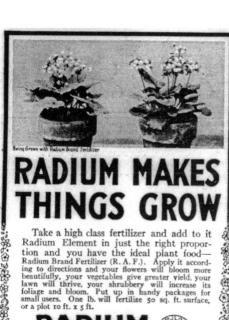
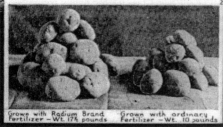
RADIUM BRAND FERTILIZER: "Radium Makes Things Grow" Brand Fertilizer [circa **1915-1920**]. (See page **61.**)

HIBAKU SEEDS: Seeds of trees affected by the **1945** bombing of Hiroshima. Artist Hiroshi Sunairi distributes hibaku seeds of various species to be replanted around the world.

クロガネモチ: ROUND LEAF HOLLY SEEDS

УМОВНІ ПОЗНАЧЕННЯ SYMBOLS

ПРИП'ЯТЬ **PRYPIAT**	Населені пункти	**Settlements**
	Міста	Towns
ІВАНКІВ **IVANKIV**	Селища міського типу	Urban type settlements
Дброва Бичка Dibrova Bychky	Села	Villages

В межах Чорнобильської зони відчуження:

practically destroyed as a result of decontamination measures, fires and other reasons — практично знищені внаслідок дезактивації, пожеж та інших причин

частково заселені "самоселами", з числом мешканців: — partially inhabited by "self-settlers" with a number of inhabitants:

до 10 — up to 10

11-30

31-50

51-100

101-150

Поза діючих меж Чорнобильської зони відчуження: — Outside actual borders of Chernobyl exclusion zone:

повністю відселені — completely evacuated

частково відселені, із числом родин, що залишилися: — partially evacuated with a number of families remained:

до 10 — up to 10

11-30

31-100

101-300

301-1000

1001-1500

Кордони та межі — Borders

Державний кордон — State

Обласні межі — Regional

Районні межі — District

Межі районів, що ліквідовані в зв'язку з утворенням Чорнобильської зони відчуження — including those liquidated due to exclusion zone formation

Межа Чорнобильської зони відчуження — Border of Chernobyl exclusion zone

Орієнтовна межа зони обов'язкового відселення — Approximate borders of compulsory evacuation zone

Межа тридцятикілометрової зони радіаційного моніторингу — Border of 30 km zone radiation monitoring

Шляхи сполучення — Communications

Магістральні автошляхи — Main highways

Інші автошляхи: 1) з твердим покриттям, 2) ґрунтові — Secondary roads: 1) with hard surface, 2) unsurfaced

Залізниці — Railroads

Специфічні об'єкти і території — Specific objects and territories

Четвертий блок ЧАЕС (об'єкт "Укриття") — 4th unit of ChNPP ("Sarcophagus")

Зовнішні контрольно-перепускні пункти — External check-points

Внутрішні контрольно-перепускні пункти — Internal check-points

Територія, що зазнала інтенсивного техногенного впливу внаслідок дезактиваційних робіт — Territory undergone to intensive technogenous activity due to decontamination activities

Територія потенційної реабілітації в межах зони відчуження — Areas of potential rehabilitation within the exlusion zone

Дані про міграцію радіонуклідів — Data concerning the radionuclides migration

Напрямки поверхневого стоку, з яким здійснюється винос радіонуклідів — Directions of surface runoff by means of which the removal of radionuclides is realized

Напрямки підземного стоку, з яким можливий винос радіонуклідів — Directions of underground runoff by means of which the removal of radionuclides is possible

Винос з поверхневим стоком р. Прип'ять стронцію-90 (67-250 Кі) та цезію-137 (10-25 Кі) — Removal from exclusion zone with Pripiat surface runoff of strontium-90 (67-250 Ci) and cesium-137 (10-25 Ci)

Біогенний винос (1-5 Кі) — Biogenic removal (1-5 Ci)

Пам'ятки історії та культури — Historical monuments and relics

Пам'ятки археології: — Archaeologic relics

стоянки — camps

поселення — settlements

городища — site of ancient towns

курганні могильники — burial mounds

наземні могильники — surface sepulchres

Пам'ятки архітектури — Architectural monuments and relics

Братські та одиночні могили — Common and individual graves

Меморіальні будинки — Memorial buildings

Монументи — Monuments

Об'єкти природно-заповідного фонду України — Objects of nature reservation of Ukraine

Заказники національного та місцевого значення, пам'ятки природи місцевого значення, пам'ятки садово-паркового мистецтва — Natural reserves of national and local significance, natural protected areas of local significance, memorial parks of horticulture and landscape art

PHOTO CREDITS

46-47: Courtesy of the Atomic Testing Museum, Las Vegas, Nevada.

65: Courtesy of Edison Art, Edison House, Edinburgh, Scotland.

70: Copyright Musée Curie (fonds ACJC)/Institut Curie.

71: Photo by author.

77: Photo courtesy of Cynthia Lowen.

82: Sadae Kasaoka, 1945: courtesy of Sadae Kasaoka; Sadae Kasaoka, 2008: photo by author.

103: Photos courtesy of Mary Osborn.

110-11: Copyright Musée Curie (fonds ACJC)/Institut Curie.

131: Photo by author.

134-35: Copyright Musée Curie (fonds ACJC)/Institut Curie.

142-43: Photos by author.

156-57: Copyright Musée Curie (fonds ACJC)/Institut Curie.

178-79: Image courtesy of Scott Lucas and Glen Hansen, INL, and Steve Owen, Sandia National Laboratories.

197: Photo by author.

1. DRAWING

2. TRANSPARENCY

3. CYANOTYPE PRINT

4. HAND-COLORED
 CYANOTYPE PRINT

A NOTE ON CYANOTYPE PRINTING

Many of the images in this book are made using a process known as cyanotype printing. To make a cyanotype, ammonium iron (III) citrate and potassium ferricyanide are combined in a soluble, light-sensitive solution that is applied to paper. A negative or transparency of the image is placed upon the coated paper. The treated paper and the transparency are pressed tightly together under glass, and then exposed to sunlight. Ultraviolet rays cause the paper's chemical coating to form insoluble ferric ferrocyanide, known as Prussian blue. This turns the paper blue in any exposed areas. When the print is washed with water and citric acid, areas that were protected from the sun by dark areas in the negative are rinsed clear.

Using this process to create the images in this book made sense to me for a number of reasons. First, the negative of an image gives an impression of an internal light, a sense of glowing that I felt captured what Marie Curie called radium's "spontaneous luminosity." Indeed, the light that radium emits is a cyan-like, faint blue. Second, because photographic imaging was central to the discovery both of X-rays and of radioactivity, it seemed fitting to use a process based on the idea of exposure. Last, I later learned, Prussian blue capsules are approved by the U.S. Food and Drug Administration as a "safe and effective" treatment for internal contamination by radioactive cesium and radioactive thallium. (After the Chernobyl nuclear disaster, cyanotype ingredients were spread on the grass in North Wales to safeguard grazing animals.)

Cyanotype prints are highly sensitive. Depending on how they are cared for, over time they can yellow or fade. However, they also have regenerative capacities: even temporarily protecting a faded print from the light can restore its original intensity.

Séance with Eusapia Palladino at the home
of Camille Flammarion, Rue Cassini, Paris,
November 12, 1898.

A NOTE ON THE TYPE

This book is set in Eusapia LR, a typeface I created based on the title pages of manuscripts at the New York Public Library. It is named after Eusapia Palladino, the Italian Spiritualist medium whose séances the Curies attended.

ACKNOWLEDGMENTS

If I were to properly express my gratitude to the people
who helped me with this book, it would be twice as long.
I owe a special debt to Jean Strouse and the Cullman Center
for Scholars & Writers at the New York Public Library;
to my editor, Cal Morgan; to my agent, Tina Bennett; to
Daniel Kevles, who spent hours with me reviewing the
scientific passages (any mistakes that remain are, of course,
my own); and to Tamara Connolly, who worked with me
on production and design. My deepest appreciation also to

Marité Amrani, Michael Barrs, Matthew Bentley, Ania
Bikont, Robin Bilardello, Kevin Callahan, Jeremy Cesarec,
Deborah Cohen, Martine Corbière & Philippe Grünebaum,
Chuck Costa, Dr. Michael Daly, Ed Epstein, Eric Epstein,
Daniel Fass, Bill Flangas, Paul Frame, Malcolm Gladwell,
Liz Goldwyn, Karen Green, Miriam Gross, Steven Guarnaccia,
Matthew Haimes, Brittany Hamblin, Charlotte Herscher,
Dr. Steven Howe, Ania Hurwic, Renaud Huyah, Carrie Kania,
Susan Kosko, Hélène Langevin-Joliot, Davie Lerner,
Anne Lester, Kim Lewis, Pattie & John Longenecker,
Cynthia Lowen, Richard McGuire, Dr. Tim Mousseau,
Alana Newhouse, Marie O'Drigny, Mary Osborn, Joseph
Papa, Andrew Pastore, Abigail Pope, Jedediah Purdy,
Susan Rabbiner, Rick & Robin Redniss, Seth Redniss,
Kailen Rogers, Alberto Rojas, Alex Rose, Jody Rosen,
Tina Schneider & Hiroshi Tachibana, Vanya Scott,
Hiroshi Sunairi, Duncan Tonatiuh, Doris Eaton Travis,
Sven Travis, Bobby Valentine, and Lawrence Weschler.

Author photo by Abigail Pope

HarperCollins books may be purchased for educational, business, or sales
promotional use. For information please write: Special Markets Department,
HarperCollins Publishers, 10 East 53rd Street, New York, NY 10022.

Library of Congress Cataloging-in-Publication Data has been applied for.

ISBN 978-0-06-135132-7

11 12 13 14 LPR
10 9 8 7 6 5 4

Lauren Redniss is the author of *Century Girl: 100 Years in the Life of Doris Eaton Travis, Last Living Star of the Ziegfeld Follies*. Her writing and drawing has appeared in numerous publications including the *New York Times*, which nominated her work for a Pulitzer Prize. She was a fellow at the Cullman Center for Scholars & Writers at the New York Public Library in 2008–2009 and is currently a New York Institute for the Humanities fellow. She teaches at the Parsons School of Design in New York City.

www.laurenredniss.com

"Writing a string quartet was
a sublime delight before the
world knew the atom bomb,
and in this respect it has not
changed — it still is."

— Ernst Toch